T0113894

# BIBLE PICTURES TO COLOR AND SHARE

## Carolyn Erickson

WESTBOW
PRESS®
A DIVISION OF THOMAS NELSON
& ZONDERVAN

Copyright © 2021 Carolyn Erickson.

All rights reserved. No part of this book may be used or reproduced by any means,
graphic, electronic, or mechanical, including photocopying, recording, taping or by
any information storage retrieval system without the written permission of the author
except in the case of brief quotations embodied in critical articles and reviews.

WestBow Press books may be ordered through booksellers or by contacting:

WestBow Press
A Division of Thomas Nelson & Zondervan
1663 Liberty Drive
Bloomington, IN 47403
www.westbowpress.com
844-714-3454

Because of the dynamic nature of the Internet, any web addresses or links contained in
this book may have changed since publication and may no longer be valid. The views
expressed in this work are solely those of the author and do not necessarily reflect the views
of the publisher, and the publisher hereby disclaims any responsibility for them.

Any people depicted in stock imagery provided by Getty Images are models,
and such images are being used for illustrative purposes only.
Certain stock imagery © Getty Images.

Interior Image Credit: Carolyn Erickson

Unless otherwise indicated, all Scripture taken from the King James Version of the Bible.

Scripture quotations marked (AMP) are taken from the Amplified Bible, Copyright © 1954,
1958, 1962, 1964, 1965, 1987 by The Lockman Foundation. Used by permission.

Scripture marked (ICB) taken from the International Children's Bible®. Copyright ©
1986, 1988, 1999 by Thomas Nelson. Used by permission. All rights reserved.

ISBN: 978-1-6642-4461-0 (sc)
ISBN: 978-1-6642-4460-3 (e)

Library of Congress Control Number: 2021919151

Print information available on the last page.

WestBow Press rev. date: 11/03/2021

# Bible Pictures to Color and Share
## Get to Know What the Bible Really Says

**Also avaiable in Spanish • Disponible también en Español**

# WELCOME TO SCRIPTURE PICTURES
## *Get to know what the Bible really says!*

**ENJOY THE PICTURES** - Each picture is an answer to the question, "What does the Bible say about this subject?" The outline that comes with the picture has scripture references to some of the places

**COLOR THE PICTURES** - Have fun coloring the pictures. You can use the colors in the pictures on the cover, or choose your own colors. It is best to use crayons, colored pencils or watercolors, whatever doesn't cover up the words.

**LOOK UP AND READ THE SCRIPTURES** - Reading scriptures in context clarifies their meaning and helps you find them again. God shows you how to apply them to your life.

**SHARE THE PICTURES AND THE SCRIPTURES** - People of all ages love to color. Parents can share them in the home. They are good for teaching most any age. Displaying them on the walls reminds us of God's truths and encourages us to continue meditating on and living by God's Word.

**PERMISSION GRANTED FOR A LIMITED NUMBER OF COPIES, ONLY FOR BIBLE CLASSES AND HOME USE.**

*Thank you to all the Family of God, Churches and individuals, who have supported this ministry through the years. All are rewarded from the Divine storehouse of God. He knows, and you know, who you are. Holy Hugs to all!*

## ABOUT THE AUTHOR

Carolyn Erickson drew her first Bible pictures while listening to the preaching of her father, Arthur Erickson, on the mission field in Peru, South America. Rev. Erickson arrived in Peru in 1928 to work with his two brothers, Leif and Walter, preaching the Gospel. Arthur would print Bible material which the brothers would distribute in the Andean villages on horseback or on foot, taking Bibles and materials by pack animals or any way they could. Many years later, some of Arthur's four growing children began to help with the printing. Carolyn, as an artist, learned graphic arts. She also began teaching Sunday School, at age thirteen, making teaching material where there was none, as in the Amazon Jungle. As an adult, after a failed marriage, she

**Rev. Carolyn Erickson - 2019**

raised a daughter and son, and studied for Bilingual Teaching and Graphic Arts, later working in both professions. She studied Bible College and received a licence to preach in 1990. In 1989 she and her widowed mother, Emma Erickson, then 84 years old, traveled ministering in Peru for a year. The material developed during that time laid the foundation of the Scripture Pictures that have been used and distributed in many places, as God continues to inspire more. In 2019 the Assemblies of God of Peru invited families of pioneer missionaries to their 100th Anniversary Celebration. Carolyn and her cousin, Robert Erickson, son of Walter, attended and were given awards honoring the ministry of their parents and also individual awards for their own ongoing involvement in the work of the Lord in Peru. Under the leadership of Victor Laguna, (now with the Lord) with help from the Walter Erickson family,

Carolyn Erickson

the Bible Institute *"Walter Erickson y Hermanos,"* in recognition of the three brothers, Leif, Arthur and Walter, was established in the *"Callejon de Huaylas,"* Peru. The Scripture Pictures material, born in Peru, will be available at that Bible College, among others. It is published in English and Spanish and will be in other languages. To God be all the glory and honor!

**CAROLYN ERICKSON © 2021**          **COLOR AND SHARE**

# SALVATION
## John 3:16

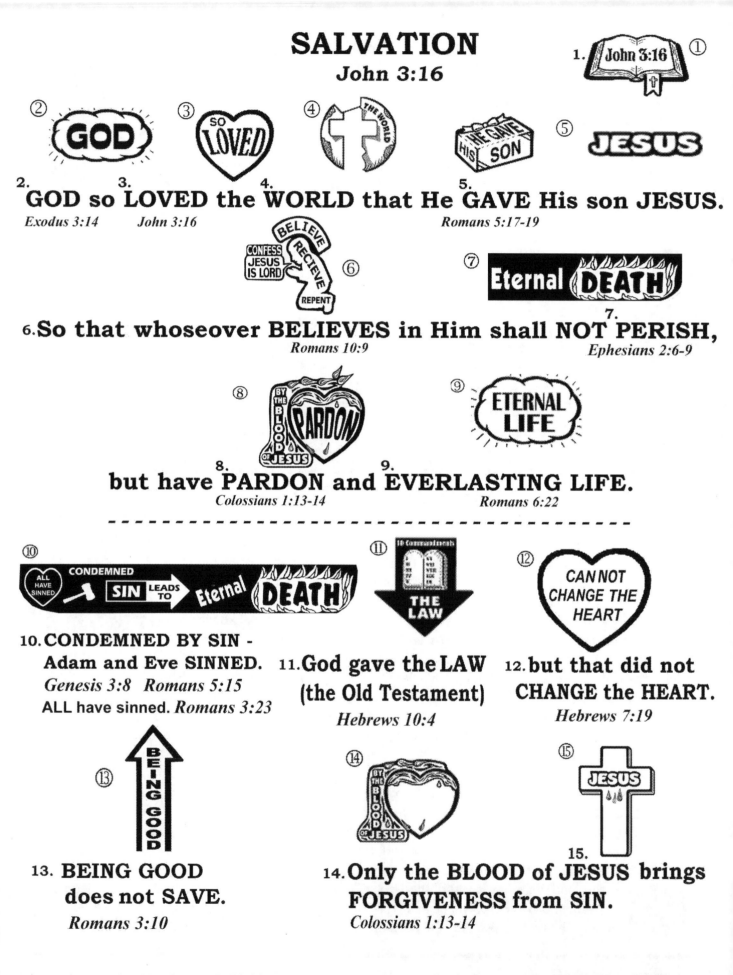

GOD so LOVED the WORLD that He GAVE His son JESUS.

*Exodus 3:14*  *John 3:16*  *Romans 5:17-19*

So that whoseover BELIEVES in Him shall NOT PERISH,

*Romans 10:9*  *Ephesians 2:6-9*

but have PARDON and EVERLASTING LIFE.

*Colossians 1:13-14*  *Romans 6:22*

- - - - - - - - - - - - - - - - - - - - - - - - - - - - - - -

10. CONDEMNED BY SIN -
Adam and Eve SINNED.
*Genesis 3:8  Romans 5:15*
ALL have sinned. *Romans 3:23*

11. God gave the LAW
(the Old Testament)
*Hebrews 10:4*

12. but that did not
CHANGE the HEART.
*Hebrews 7:19*

13. BEING GOOD
does not SAVE.
*Romans 3:10*

14. Only the BLOOD of JESUS brings
FORGIVENESS from SIN.
*Colossians 1:13-14*

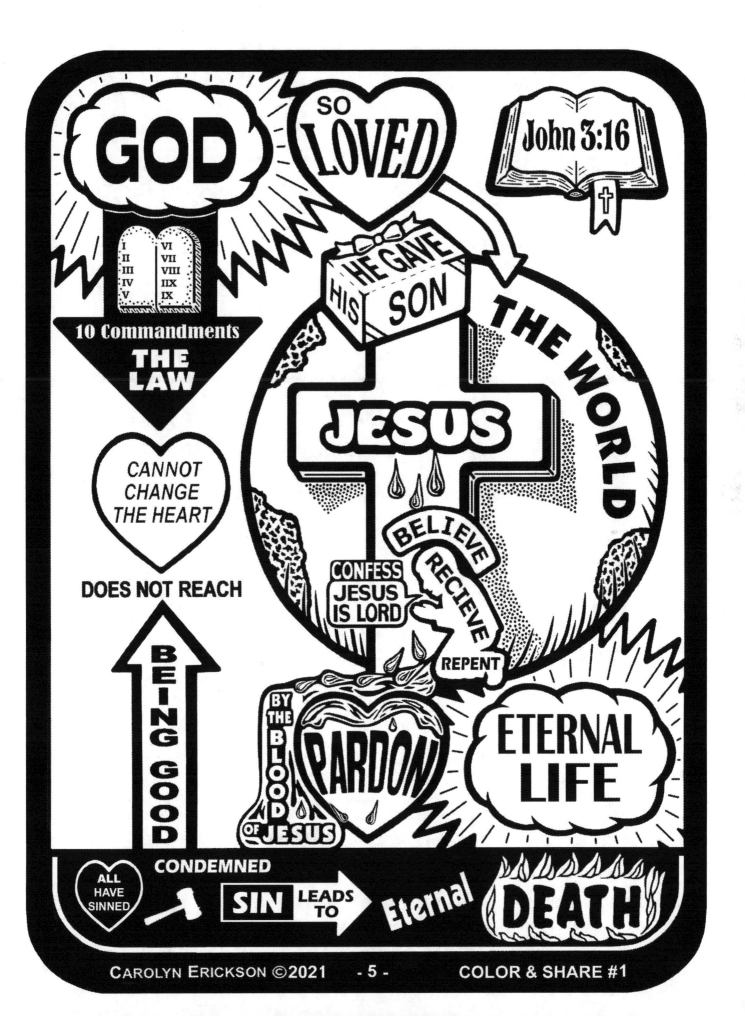

# HOW to PRAY

### "Praying Always…" 1 Thessalonias 5:17

**1. PRAYING ALWAYS** - Always be aware of pleasing God. *1 Thessalonians 5:17* *"… He will direct your paths." Proverbs 3:5-7*

**2. THE LORD'S PRAYER** - Jesus gave an example of HOW to PRAY. *Matthew 6:9-14*

**3. MOTIVATION** - When we ask "in Jesus' name," *John 14:13* our MOTIVATION must not be selfish *James 4:3*

**4. HUMBLE** - We come to God with HUMBLE hearts. *2 Chronicles 12:7*

**5. ASK** - Ask for your needs, be SPECIFIC. *John 26:23-24*

**6. BIBLICAL** - Prayer must agree with GOD'S WORD. *Hebrews 4:12*

**7. FAITHFUL** - Don't give up, be FAITHFUL in prayer. *Luke 11:7*

**8. PRAY WITH FAITH** - Give thanks in advance, by FAITH. *2 Peter 3:9*

**9. GIVE THANKS** - With a grateful heart, giving THANKS. *Phillipians 4:6*

**10. PRAYER is to be HEARTFELT and PERSISTENT.** *James 5:16*

**11. FORGIVE and ASK FORGIVENESS.** *Matthew 5:23-24*

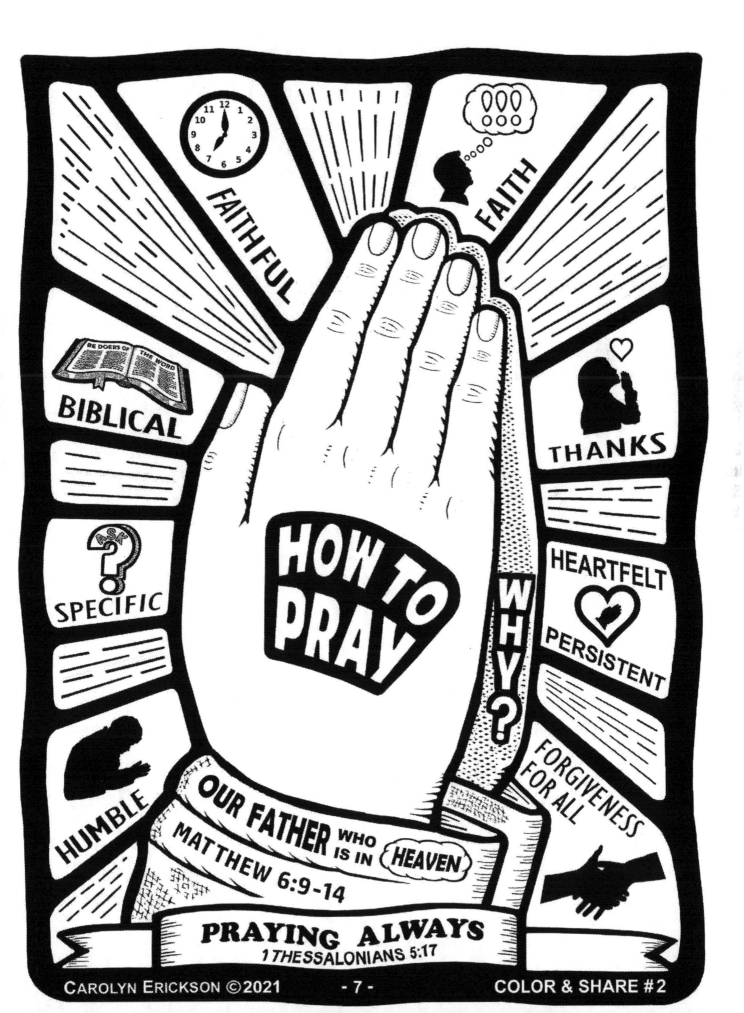

# BIBLE STUDY
## *ASK, SEEK, KNOCK... Matthew 7:7*

**1. BIBLE STUDY -**
*"Study...to present yourself to God approved, a workman who has no reason to be ashamed, accurately handling and skillfully teaching the word of truth."*
*2Timothy 2:15 AMP*

**2. THE HOLY SPIRIT GIVES UNDERSTANDING**
*"that the eyes of your heart... may be flooded with light by the Holy Spirit.."*
*Ephesians 1:18 AMP*

**3. TAKE TIME to STUDY -**
*"Practice and work on these things; be absorbed in them, so that your progress will be evident to all."*
*1 Timothy 4:15 AMP*

**4. THE WORD of GOD is ETERNAL**
*"The living and everlasting Word of God."*
*1 Peter 1:23 AMP*

**5. BE DOERS OF THE WORD**
*"Be people who DO what the word says, not...only hear it. Such people are deceiving themselves."* *James 1:22 AMP*

## A PATTERN FOR BIBLE STUDY

**6. ASK, SEEK, KNOCK**
From Matthew 7:7

**7. STEP ONE:**
## ASK -
Ask a SPECIFIC QUESTION.

**8. STEP TWO:**
## SEEK-
Read FOR YOURSELF what the Bible really says.
*Hebrews 5:12-14*

### ASK THESE FOUR QUESTIONS:

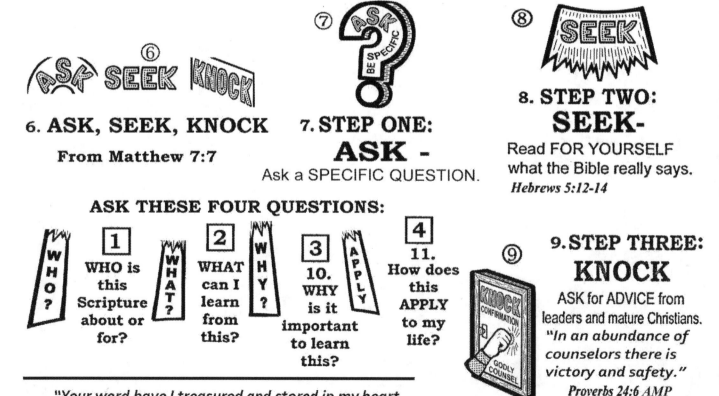

**1** WHO is this Scripture about or for?

**2** WHAT can I learn from this?

**3** 10. WHY is it important to learn this?

**4** 11. How does this APPLY to my life?

**9. STEP THREE:**
## KNOCK
ASK for ADVICE from leaders and mature Christians.
*"In an abundance of counselors there is victory and safety."*
*Proverbs 24:6 AMP*

*"Your word have I treasured and stored in my heart that I may not sin against You." Psalm 119:11 AMP*

**CAROLYN ERICKSON © 2021**   **COLOR AND SHARE # 3**

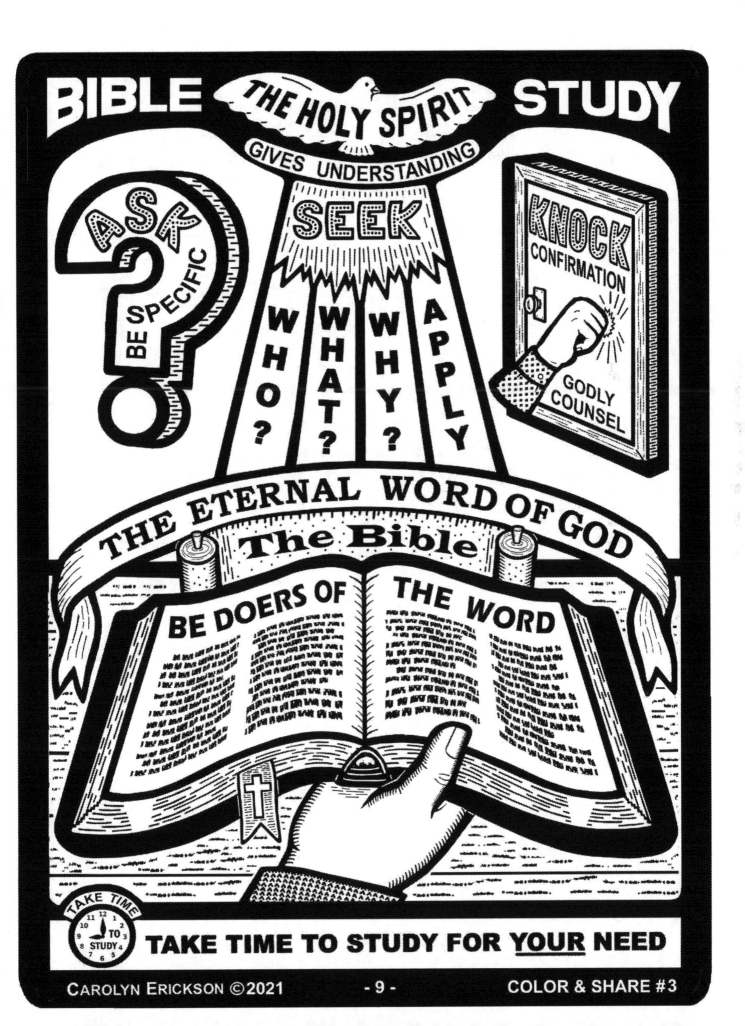

# FRUIT OF THE SPIRIT OF GOD
## And the Actions of Love
### Galatians 5:23, 23 - 1 Corinthians 13:4-8

**1. The CHARACTER of GOD shows through the FRUIT (evidence) of HIS SPIRIT in believers.**

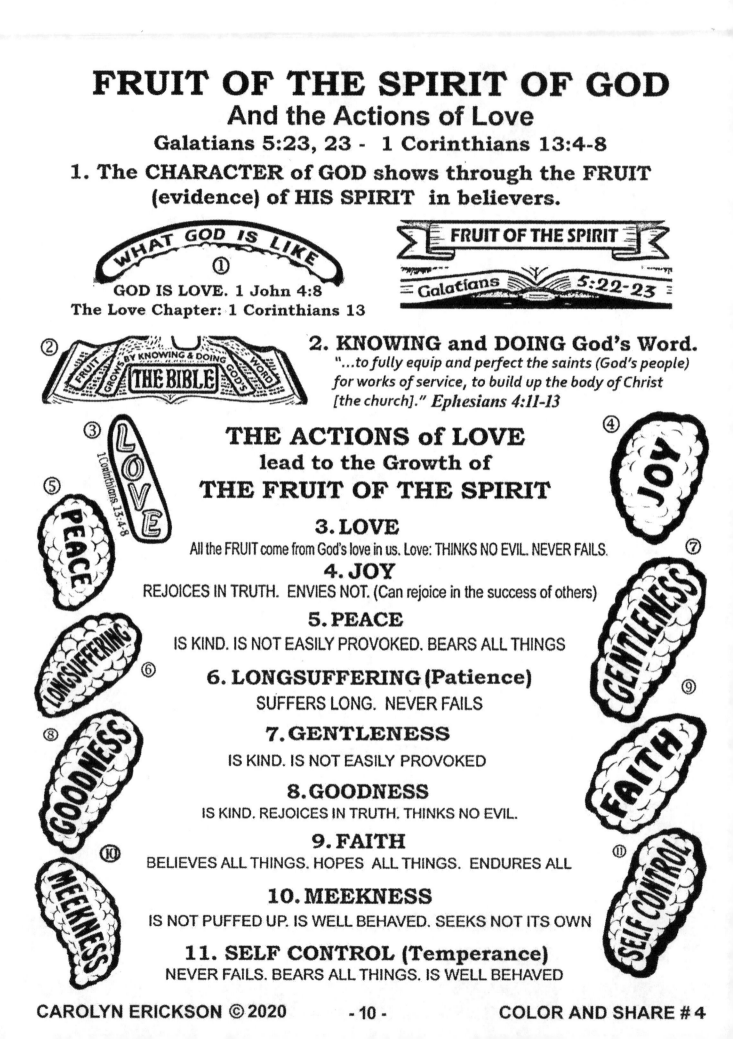

WHAT GOD IS LIKE ①

GOD IS LOVE. 1 John 4:8
The Love Chapter: 1 Corinthians 13

FRUIT OF THE SPIRIT
Galatians 5:22-23

② GROW BY KNOWING & DOING — FRUIT — WORD — THE BIBLE — GOD'S

**2. KNOWING and DOING God's Word.**
*"...to fully equip and perfect the saints (God's people) for works of service, to build up the body of Christ [the church]." Ephesians 4:11-13*

## THE ACTIONS of LOVE
### lead to the Growth of
## THE FRUIT OF THE SPIRIT

③ LOVE 1 Corinthians 13:4-8

④ JOY

⑤ PEACE

⑦ GENTLENESS

### 3. LOVE
All the FRUIT come from God's love in us. Love: THINKS NO EVIL. NEVER FAILS.

### 4. JOY
REJOICES IN TRUTH. ENVIES NOT. (Can rejoice in the success of others)

### 5. PEACE
IS KIND. IS NOT EASILY PROVOKED. BEARS ALL THINGS

### 6. LONGSUFFERING (Patience)
SUFFERS LONG. NEVER FAILS

⑥ LONGSUFFERING

⑨ FAITH

### 7. GENTLENESS
IS KIND. IS NOT EASILY PROVOKED

### 8. GOODNESS
IS KIND. REJOICES IN TRUTH. THINKS NO EVIL.

⑧ GOODNESS

### 9. FAITH
BELIEVES ALL THINGS. HOPES ALL THINGS. ENDURES ALL

⑪ SELF CONTROL

### 10. MEEKNESS
IS NOT PUFFED UP. IS WELL BEHAVED. SEEKS NOT ITS OWN

⑩ MEEKNESS

### 11. SELF CONTROL (Temperance)
NEVER FAILS. BEARS ALL THINGS. IS WELL BEHAVED

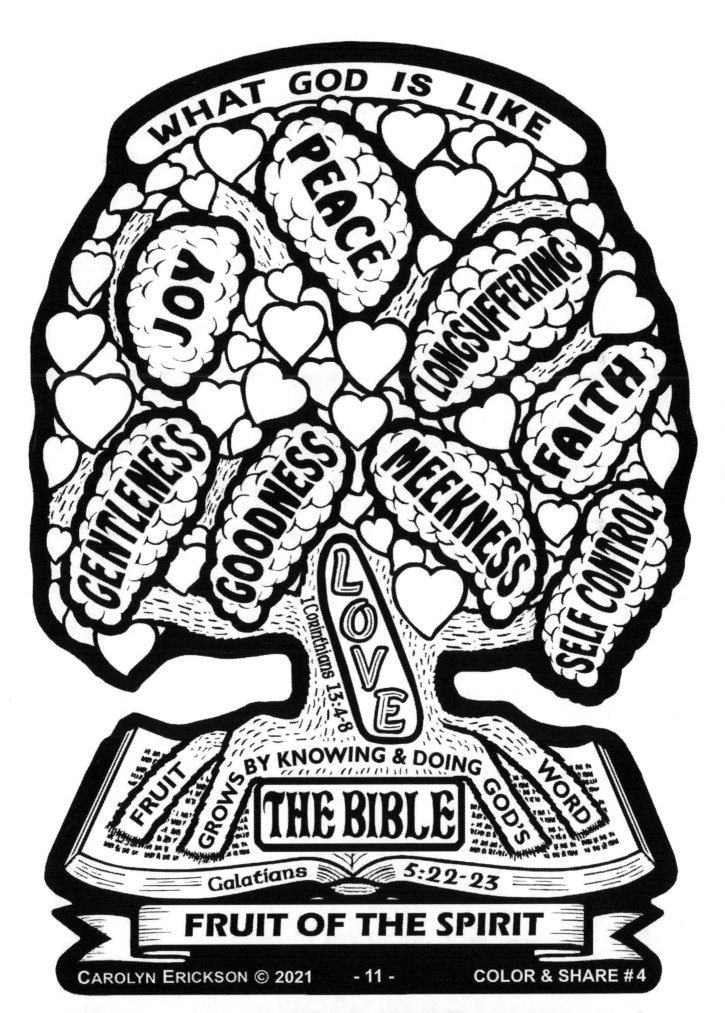

WHAT GOD IS LIKE

PEACE

JOY

LONGSUFFERING

FAITH

GENTLENESS

GOODNESS

MEEKNESS

SELF CONTROL

LOVE

I Corinthians 13:4-8

FRUIT GROWS BY KNOWING & DOING GOD'S WORD

THE BIBLE

Galatians 5:22-23

FRUIT OF THE SPIRIT

CAROLYN ERICKSON © 2021      - 11 -      COLOR & SHARE #4

# GIFTS OF THE SPIRIT OF GOD

①  **First Corinthians 12:4-11**

**1. THE GIFTS OF THE SPIRIT -**
The Gifts are listed in 1 Corinthians 12:4-11.

② **GIFTS of the SPIRIT of GOD**

**2.** The POWER of Spiritual Gifts comes from, and belongs to, God. *1 Corinthians 12:4-11*

③ **GIFTS > LOVE**

**3. Desire the Gifts, but the MORE excellent way is LOVE.** *1 Corinthians 12:31*

**MOTIVATED BY LOVE**

I Corintians 13 describes the ACTIONS of LOVE.

④ **USING THE GIFTS** 1 Corinthians 14

**4.** 1 Corinthians 14 tells HOW to USE the Gifts.

⑤  **KNOW**

**5. 3 Gifts of KNOWING**

⑥  **KNOWLEDGE**

**6. Knowledge from a SUPERNATURAL source.** *Luke 5:22*

⑦ **WISDOM**

**7. What to DO with special knowledge.** *Luke 21:15*

⑧ **DISCERNMENT**

**8. Knowing the SOURCE of special knowledge, from God, Satan or ourself?** *Hebrews 5:14*

⑨  **SPEAK**

**9. Gifts of SPEAKING**

⑩ **TONGUES**

**10. Speaking an unlearned KNOWN language, or an ANGELIC one.** *Acts 1:8, 2:8. 1 Cor. 13:1*

⑪ **INTERPRETATION OF TONGUES**

**11. The ability to INTERPRET unknown languages.** *1 Cor. 14:13-15*

⑫ **PROPHECY**

**12. Speaking the MIND of GOD, for edification and exhortation.** *1 Corinthians 14:1-5*

⑬  **DO**

**13. Gifts of DOING**

⑭ **FAITH**

**14. A sure KNOWING and CONFIDENCE of the will of God.** *Romans 12:3*

⑮ **MIRACLES**

**15. *Must BREAK the laws of nature and bring GLORY to God.* ** *Judges 6:37*

⑯ **HEALINGS**

**16. *Instant or gradual, Physical Mental or Emotional HEALING.* ** *Matthew 10:1*

**17. OTHER GIFTS:** ⑰ •Helps •Administration...*Romans 12:6-8*
•Apostleship •Ministry •Teaching •Encouragement
•Giving •Leadership •Mercy... *1 Corinthians 12:28*

⑱ **UNDER CONTROL and ORDERLY**

**18. *God's gifts do not come in a "showy or frightening way." They are to be orderly. "Let all things be done DECENTLY and in ORDER."* ** *I Corinthians 14:40*

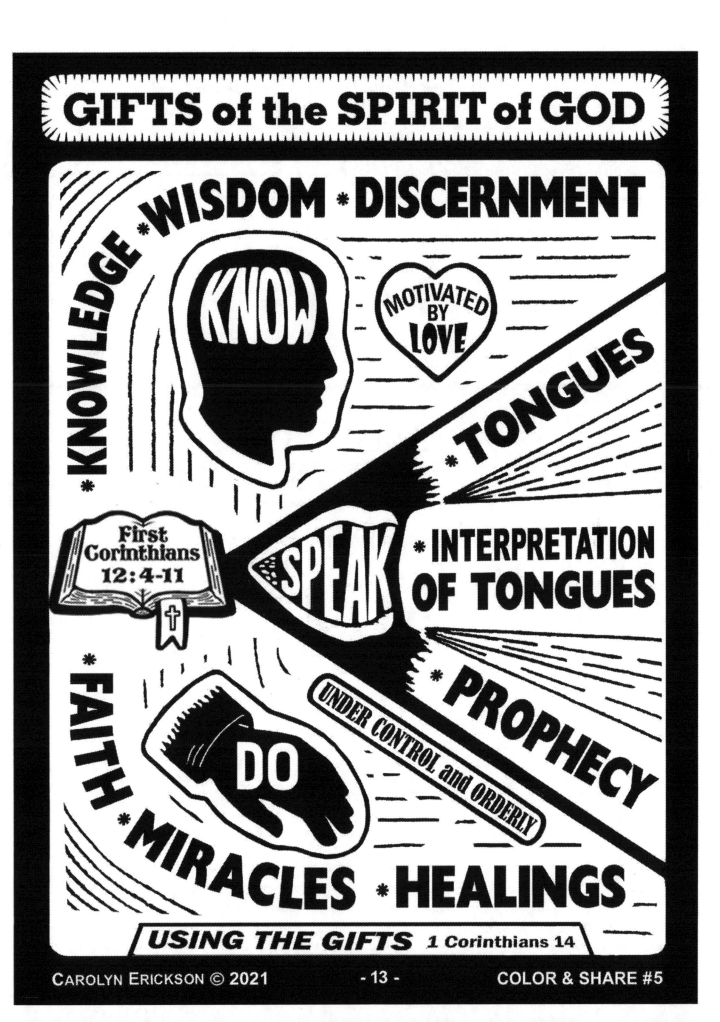

CAROLYN ERICKSON © 2021

# MONEY
## *The True Riches - Luke 16:10-11*

**1. GOD LOVES A CHEERFUL GIVER** – Remember that we are advancing the Kingdom of God. This gives us the right ATTITUDE toward giving. *Let each one give just as he has decided in his heart, not under compulsion, for God loves a cheerful giver, [whose heart is in his gift].* *2 Corinthians 9:5-7 AMP*

①

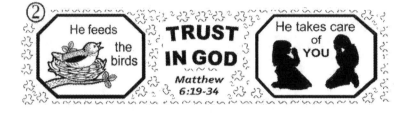

**2. TRUST** – Knowing that God is the SOURCE of all provision, teaches us to TRUST Him. *"Look at the birds of the air... your heavenly Father keeps feeding them. Are you not worth much more than they?" Matthew 6:19-34 AMP*

③

④

⑤

**3. THE TITHE** - God promised to bless the tithe. He said "Try me" *Malachi 3:10.* Jesus did NOT end the TITHE, but it is the HEART ATTITUDE that matters. *Luke 11:42*

**4. THE OFFERING** – This is what we give AFTER the tithes. Jesus said that the widow who gave two small coins, gave more than the rich. She was trusting God. *Luke 21:1-4.*

**5. YOU CANNOT SERVE GOD AND MONEY** - *"You cannot serve both GOD and mammon [ your earthly possessions or anything else you trust in and rely on...]" Luke 16:13 AMP*

**6. THE TRUE RICHES** – *"...if you have not been faithful in the use of earthly wealth, who will entrust the TRUE riches to you?"* (the knowledge of God.) *Luke 16:11-12 AMP*

⑥

**7. DO NOT STORE UP TREASURES ON EARTH -** *"But store up ... treasures in HEAVEN ...for where your treasure is... there your heart will be also." Matthew 6:19 AMP*

⑦

**8. WHAT YOU PLANT IS WHAT YOU HARVEST / REAP -**

For *"the one who sows to his FLESH [sinfulness, worldliness, impulses] will reap from the flesh ruin and destruction, but the one who sows to the SPIRIT will from the Spirit reap eternal life." Galatians 6:7- 8. AMP*

⑨

**9. THE LOVE OF MONEY** - *For the LOVE of money [that is, the greedy desire for it ] is a ROOT of all sorts of EVIL, and some by longing for it have wandered away from the faith and pierced themselves [through and through] with many sorrows." 1 Timothy 6:10 AMP*

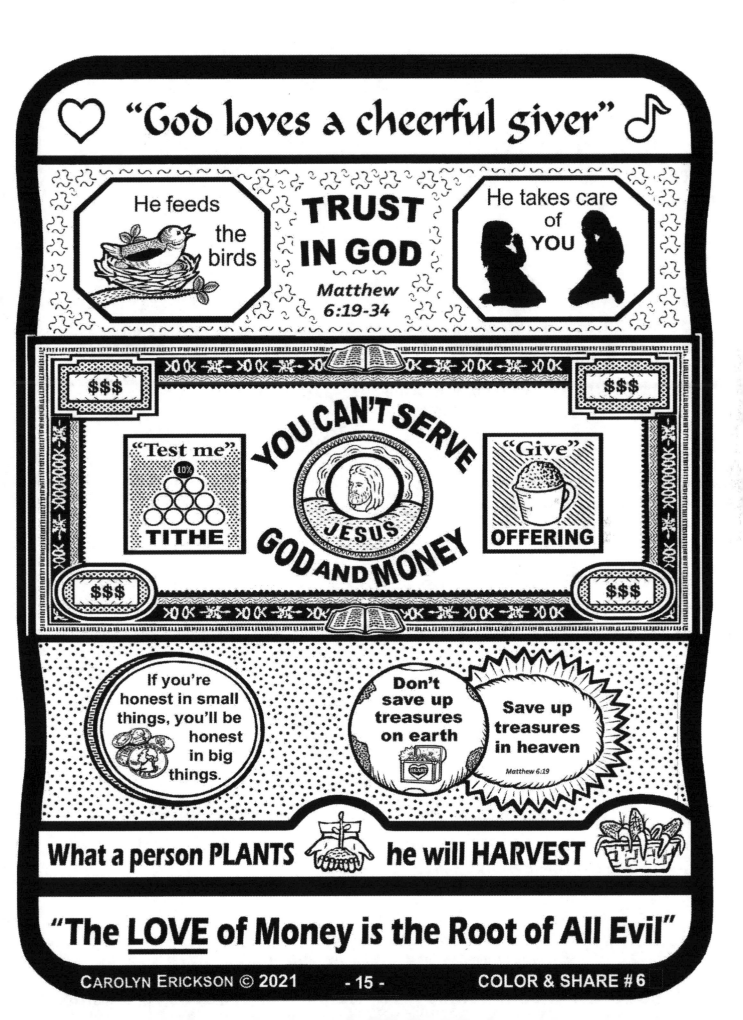

# MARRIAGE

### *"THEY SHALL BECOME ONE FLESH" Genesis 2:24*

## MARRIAGE ①

**1. GOD CREATED MARRIAGE -** God created MAN, Adam, then He created WOMAN, Eve, and brought her to the man. *Genesis 2:21-22*

## "THEY SHALL BECOME ONE FLESH"

**2. THEY SHALL BECOME ONE FLESH** *Genesis 2:24*

## WHAT BOTH SHOULD DO

**3. LOVE ONE ANOTHER** *1 John 4:11*
*"Be LOVING, gracious and kind."*
*1 Peter 3:8 MEV*

**5. BE IN UNITY.** Learn to be in agreement.
*1 Peter 3:8*

**4. The ACTIONS of LOVE like FAITH PEACE, PATIENCE AND KINDNESS,** should flow between them for a successful relationship. *1 Corinthians 13*

## WHAT THE HUSBAND SHOULD DO

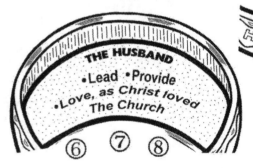

**6. LEAD** the home, in subjection to God. *Ephesians 5:23*

**7. PROVIDE** for the home. *Genesis 3:17*

**8. LOVE AS CHRIST LOVED -** *"Husbands, love your wives [seek the highest good for her and surround her with a caring, unselfish love], just as Christ also loved the church..." Ephesians 5:25*

## WHAT THE WIFE SHOULD DO

**9.** *"HAVE RESPECT for her husband."*
*Ephesians 5:33 KJV 1995*

**10. GIVE HELP** that is needed. *Genesis 3:20-23*

**11. A GENTLE and QUIET SPIRIT,**
*"... is of great worth to God." 1 Peter 3:3-4*

**12. AN UNBELIEVING SPOUSE -** A believer can remain married to an unbeliever as long as they can live in PEACE. If the unbeliever leaves, the believer is set free. *1 Corinthians 7:12-16*

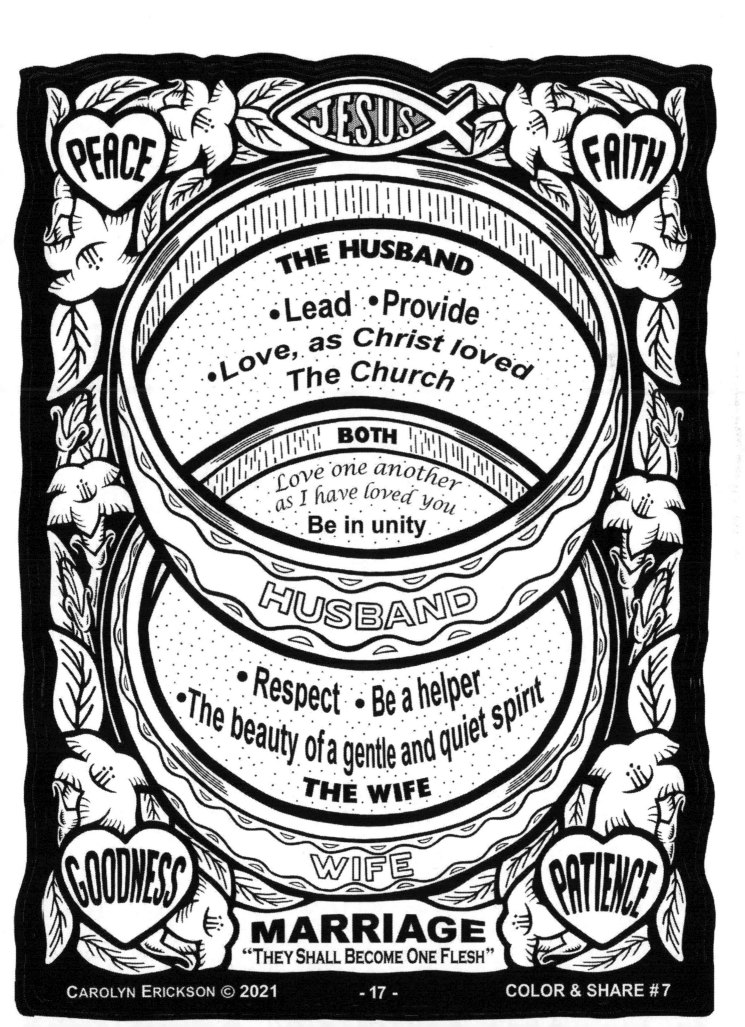

PEACE

FAITH

JESUS

THE HUSBAND
• Lead • Provide
• Love, as Christ loved
The Church

BOTH
*Love one another as I have loved you*
Be in unity

HUSBAND

• Respect • Be a helper
• The beauty of a gentle and quiet spirit
THE WIFE

WIFE

GOODNESS

PATIENCE

MARRIAGE
"They Shall Become One Flesh"

CAROLYN ERICKSON © 2021

COLOR & SHARE #7

# WATER BAPTISM

### *Repent and be Baptized*

①

②

*In the name of the FATHER, SON and HOLY SPIRIT*
③

**1. JESUS WAS BAPTIZED**
As our example, he was BAPTIZED by John the Baptist. The Holy Spirit appeared as a dove. *Matthew 3:13-17*

**2. REPENT AND BE BAPTIZED –**
John the Baptist preached repentance from SIN. *Acts 2:38* Repentance means, "to turn completely around."

**3. "BAPTIZE in the NAME of the FATHER, SON and the HOLY GHOST"** - This was Jesus' command. *Matthew 28:19*

④

⑤ **WATER BAPTISM**

⑥

**4. SAVED BY GRACE –**
Being BAPTIZED does NOT SAVE us. *Ephesians 2:8* Our HEARTS must be changed. *Luke 11:39*

**5. WATER BAPTISM –**
Baptism is symbolic of DEATH to the old life. *Romans 10:9* BAPTIZE is "Baptizdo" in Greek, means "to sink, to dip."

**6. "CONSIDER YOURSELF DEAD to SIN"–**
This involves a CHOICE. Our "OLD MAN" (the sinful nature) is "crucified with Him (Christ)." *Romans 6:6* We then choose to "Reckon (consider) ourselves DEAD to SIN." *Romans 6:11*

⑦

⑧

⑨

**7. BURIED with CHRIST** - *"Christ died for our SINS according to the scriptures..." 1 Corinthians 15:3* BURIED with him *Romans 6:6*

**8. RAISED UP with HIM** - "If we have been united with him in his DEATH, we will certainly also be united with him in his RESURRECTION..." *Romans 6:5-7*

**9. TO LIVE UNTO GOD** - Our new life is a new beginning. "...that he liveth, he LIVETH unto GOD." *Romans 6:10* This is being BORN AGAIN. Jesus answered, "Ye must be born again." *John 3:5-7*

⑩

⑪

⑫

⑬

**10. WALK IN NEWNESS OF LIFE** - We are born again to walk in "NEWNESS of LIFE" *Romans 6:4* The new life is not about rules and regulations, but freedom in Christ. "... if ye be dead with Christ... why... are ye subject to ordinances...?" *Colossians 2:18-23*

**11. We NOW SIT in HEAVENLY PLACES in CHRIST JESUS**- Spiritually, He "hath raised us up together, and made us sit in HEAVENLY PLACES in Christ Jesus..." *Ephesians 2:5-7*

**12. BAPTIZED INTO THE BODY** - Water Baptism brings us into ONE with the BODY of CHRIST. "For by one Spirit are we all baptized into one body..." *1 Corinthians 12:13*

**13. TEACH OTHERS** - Jesus commanded, "GO unto all the world...preaching the gospel ...and TEACHING them to OBSERVE ALL THINGS... I am with you always, even unto the end." *Matthew 28:20*

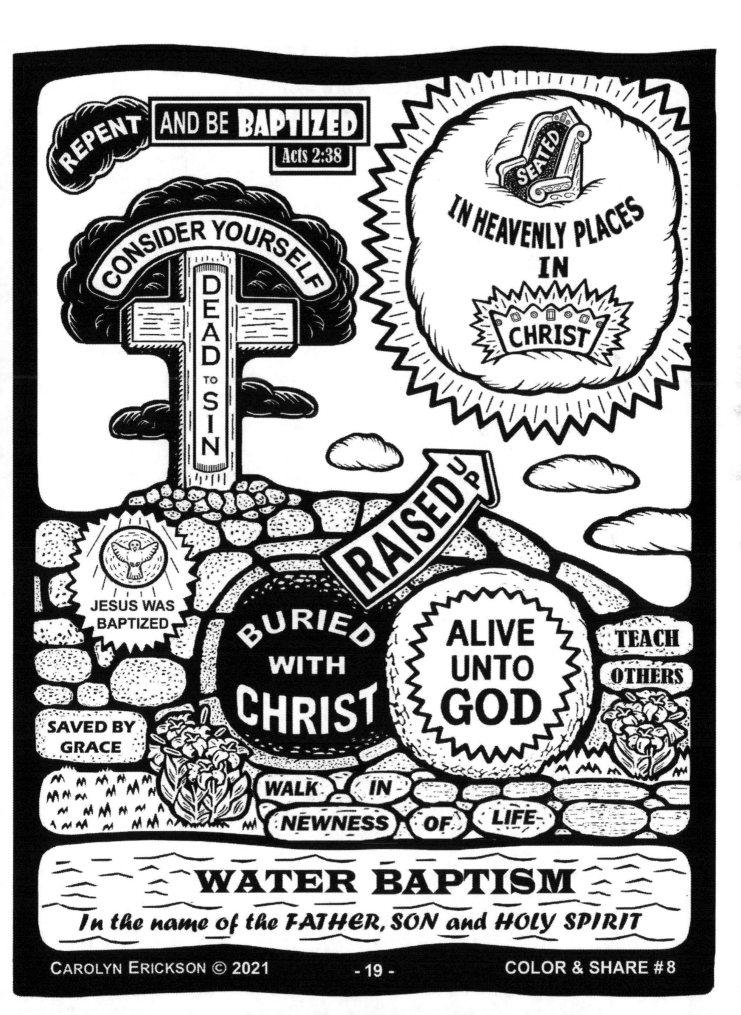

# COMMUNION - THE LAST SUPPER

*"Do this in remembrance of me."*
*Luke 22:19*

①

**1. IN REMEBRANCE OF ME -**
*Jesus said, "This cup is new Testament in my Blood.*
***DO THIS IN REMEMBRANCE*** *of me."  Luke 22:19*

②

**OLD TESTAMENT**

**2. THE OLD COVENANT -**
(Testament) - God made a COVENANT with Israel. Under that LAW of the Old Covenant, there was animal SACRIFICE for SINS. *Exodus 20:24*
*Hebrews 9:22* But the law "made nothing perfect." *Hebrews 7:19*

③

**NEW TESTAMENT**

**3. The NEW COVENANT -**
(Testament) – God sent His son to be a PERFECT SACRIFICE for SIN. "Lamb of God." *John 1:36*
He is the MEDIATOR of a BETTER COVENANT. *1 Timothy 2:4-6,*
The law of God is WRITTEN ON our HEARTS. *Hebrews 8:5-10*
*1 Corinthians 13:1*

④

**4. THE CUP - JESUS' BLOOD -**
Communion REMEMBERS the sacrifice of the blood and body of Jesus. The night before He was to die, Jesus shared a cup of "fruit of the vine," translated as "wine" with his disciples as a reminder of His BLOOD. *Matthew 26:28*

⑤

**5. FOR SALVATION - FORGIVENESS OF SIN -**
*"For as through the one man's disobedience [Adam] the many were made sinners, even so through the obedience of the One, [Jesus] the many will be made righteous."*
*Romans 5:19 NASB*

**6. THE BREAD, JESUS' BODY -**
⑥
The BREAD is a symbol of the BODY of Jesus. *Jesus said,*
*"This is My body which is given for you; do this in remembrance of Me." Luke 22:19*

⑦

**7. "BY HIS STRIPES WE ARE HEALED" -**
*Jesus was beaten for our sins. "By his stripes we are HEALED…" Isaiah 53:4-6*
Jesus healed the sick. Some kinds of sickness are caused by sin; some are not.
*John 9:1-3*

⑧

**8. "EXAMINE YOURSELVES"** - Take communion seriously. Each person is to *"… EXAMINE himself,"* to make certain we are not *"taking unworthily."*
*1 Corinthians 11:27-31*

⑨

**9. THE BODY OF CHRIST ON EARTH -**
The *"body of believers,"* are His representatives on earth. *Colossians 1:18, 2:19*
*1 Corinthians 12:27* Every part of the BODY supplies the need of the others, *"in love."*
*Ephesians 4:16*

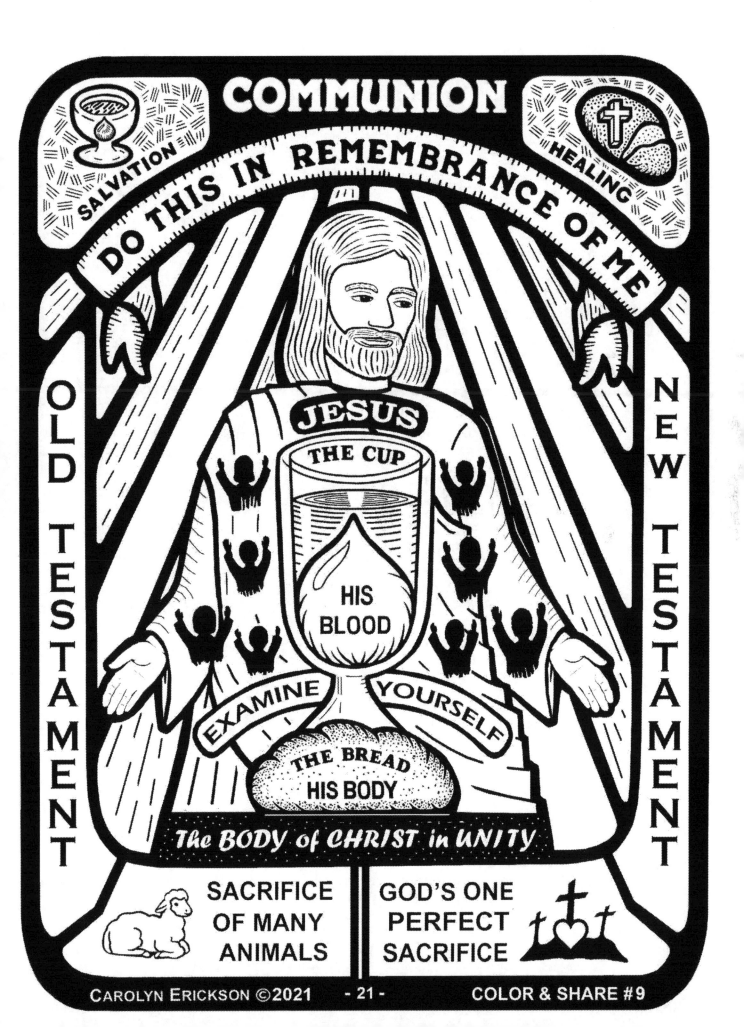

COMMUNION

SALVATION

HEALING

DO THIS IN REMEMBRANCE OF ME

OLD TESTAMENT

NEW TESTAMENT

JESUS

THE CUP

HIS BLOOD

EXAMINE YOURSELF

THE BREAD
HIS BODY

The BODY of CHRIST in UNITY

SACRIFICE OF MANY ANIMALS

GOD'S ONE PERFECT SACRIFICE

# THE CHURCH
## *Lively Stones - 1 Peter 2:5*

 **① LIVING STONES**

**1. THE CHURCH** – The Church is a SPIRITUAL building, BELIEVERS are *"LIVELY STONES...built up into a Spiritual house." 1 Peter 2:5* Each stone has its own place and job. We should NOT COMPARE ourselves. *1 Corinthians 10:12*

**2. THE TRINITY -**
*For there are three that bear record in heaven, the Father, the Word, and the Holy Ghost: and these three are one.*
*1 John 5:8*

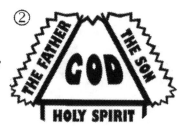

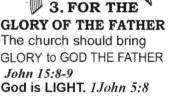

**3. FOR THE GLORY OF THE FATHER** The church should bring GLORY to GOD THE FATHER *John 15:8-9* God is LIGHT. *1John 5:8*

**4. JESUS, THE SON-** Jesus is the LIVING WORD of God. *John 14:6*

**THE CORNERSTONE and FOUNDATION -** The Church is built upon the ROCK, who is Jesus, *1 Corinthians 10:4* As CHIEF CORNERSTONE. All has to be MEASURED by Him. *1 Peter 2:6*

**5. THE HOLY SPIRIT-** When Jesus returned to the Father, he sent the HOLY SPIRIT who TEACHES and GUIDES. *John 14:2*

**6. THE BODY OF CHRIST, THE CHURCH**
Jesus is the HEAD of the CHURCH. We follow His EXAMPLE, *Colossians 1:18, 2:19* We are His representatives here on earth. *"YOU are the BODY OF CHRIST." I Corinthians 12:27*

**7. THE LIGHT OF THE WORLD**
Jesus is the LIGHT of the world. *John 8:12* As His BODY, we share God's love. *"YOU shine as LIGHTS in the world." Philippians 2:15 AMP*

**8. COVERED BY LOVE -**
*"... LOVE COVERS and overwhelms all transgressions."* [forgiving and overlooking another's faults] *Proverbs 10:12 AMP* God's love in us is shown by the FRUIT of the SPIRIT *Galatians 5:22-23*

**9. A HOUSE OF PRAYER** Jesus said, *"My house shall be called a house of PRAYER." Matthew 21:13*

**10. FIVE GIFT MINISTRIES** *Ephesians 4:11*

**⑪ APOSTLES PROPHETS**

**11. APOSTLES AND PROPHETS** – advise and OVERSEE the church to keep it in the way of JESUS' TRUTH. *Ephesians 2:20*

**⑫ PASTORS TEACHERS**

**12. PASTORS AND TEACHERS** - are for the *"perfecting of the saints...for MINISTRY." Ephesians 4:12* For our own good, we are to OBEY them. *Hebrews 13:17*

**13. EVANGELISTS** - They lead in obeying Jesus' mandate to, *"GO... and preach the Gospel.." Matthew 28:19-20* This is a call for all believers, but some have special ability to do it.

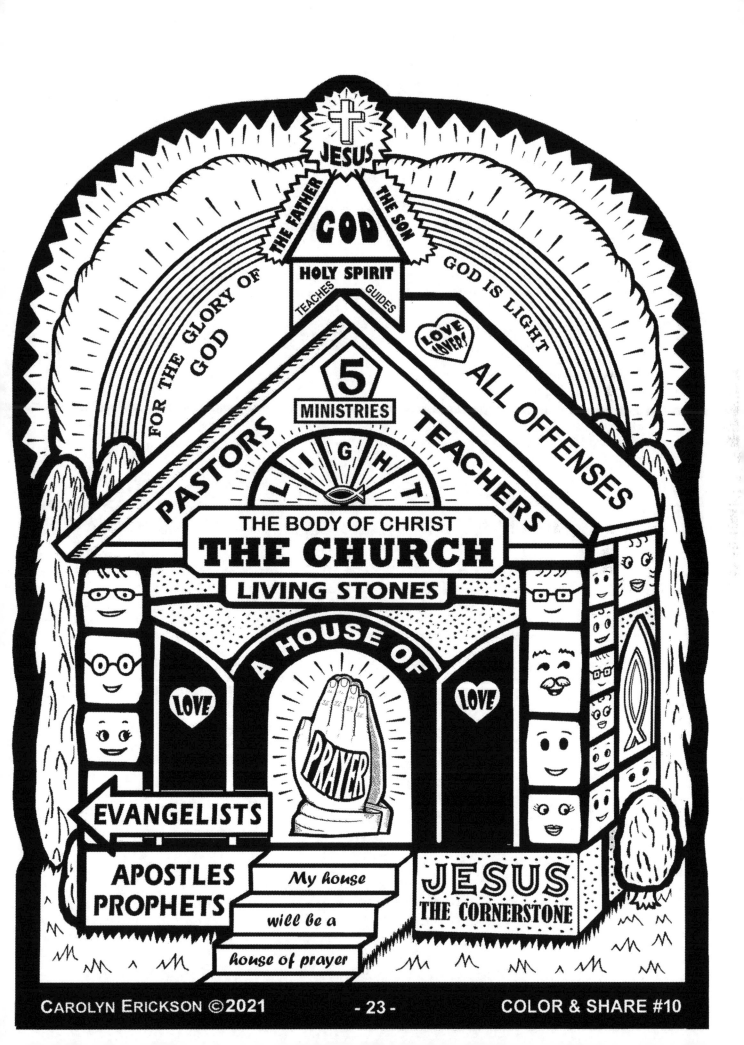

CAROLYN ERICKSON ©2021    COLOR & SHARE #10

# THE GOOD SOLDIER

## CALLED TO BE SOLDIERS - *II Timothy Chapter 2*

 ①

**1. THE GOOD SOLDIER** – As part of GOD'S ARMY, the Christian GOOD SOLDIER *(vs. 3)* cooperates with others. *"By ONE Spirit, one BODY."* *1 Corinthians 12:13*

**ENDURES HARDSHIP WITHOUT COMPLAINT** ②

**2. ENDURES HARDSHIP** – The Good soldier does not complain. *(vs. 3)* *"Joyful in tribulation..."* *2 Corinthians 7:4*

③

**3. PLEASES THE CAPTAIN** – He PLEASES THE CAPTAIN *(vs.4)* and OBEYS THE RULES. *(vs. 5)* *"Obey, for they watch for your souls."* Hebrews 13:17

④ **DOES NOT GET ENTANGLED**

**4. DOES NOT GET ENTANGLED** – He Is not tied down with material things. *(vs. 4)* NARROW is the way that leads to LIFE." *Matthew 7:14*

**OUR WEAPONS ARE NOT CARNAL, BUT MIGHTY THROUGH GOD...** *2 Corinthians 10:4-5* ⑤

**5. OUR WEAPONS ARE SPIRITUAL** – "For though we walk in the flesh, we do not war after the flesh, THE WEAPONS... ARE...mighty through God. *"We can demolish every DECEPTIVE FANTASY. We capture every THOUGHT... and make them OBEY Christ."* 2 Corinthians 10:4-5 AMP* The war is ...against Principalities, Powers, Rulers of the Darkness of this world, against Spiritual Wickedness in High Places. *(vs. 12)*

## PUT ON THE WHOLE ARMOR OF GOD

 **EPHESIANS 6:10-18** ⑥

**6. PUT ON the WHOLE ARMOR of God** – The instruction is very clear. *(vs. 10-18.)* This is something we DO every day. *"Put ON the NEW NATURE ... created in God's image."* Ephesians 4:24 AMP

⑩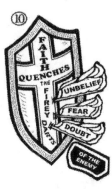
FAITH QUENCHES THE FIERY DARTS / UNBELIEF / FEAR / DOUBT / OF THE ENEMY

⑦ **TRUTH**

**7. BELT of TRUTH** – The Armor for the vital organs is TRUTH. *(vs. 14)* Integrity is our protection. *"He who walks and lives uprightly... shall NEVER be moved."* Psalm 15:2-5

⑧ **RIGHTEOUSNESS**

**8. BREASTPLATE of RIGHTEOUSNESS** - This protects the Heart, *(vs.14)* keeping it from wrong desires and affections. *"So put to DEATH and deprive of power the evil longings of your EARTHLY body..."* Colossians 3:5 AMP

⑨ **GOSPEL of PEACE**

**9. SHOES OF PEACE** - Everywhere you go your FEET are prepared with the GOSPEL OF PEACE. *(vs.15)* *"To guide our feet into the way of peace..."* Luke 1:79

**10. Above ALL take the SHIELD of FAITH** – *(vs. 16)* to quench the FIERY DARTS of the Wicked. If we have unbelief, fear or doubt, we are open to the attacks of the enemy. *"But he must ask in FAITH, without doubting..."* James 1:6-7 *"I fear NO evil, for You are with me..."* Psalm 23:4

⑪ **SALVATION**

**11. Put on the HELMET of SALVATION** – Protects the mind, with the assurance of SALVATION. *(vs.17)* *"NOTHING will be able to separate us from the LOVE of God, in Christ Jesus."* Romans 8:39

⑫ **THE WORD OF GOD**

**12. THE WORD OF GOD** – *"The SWORD of the Spirit, which is the Word of God."* *(vs.17)* Speaking God's truth in love has POWER. Ephesians 4:15

⑬ **PRAYING ALWAYS**

**13. PRAYING ALWAYS...** with all PRAYER and supplication in the Spirit. *(vs. 17)* Prayer is spiritual warfare. *"PRAY without ceasing."* 1 Thessalonians 5:17

**FIGHTS**
**We FIGHT with the WORD of GOD and PRAYER**

 **THE WORLD** ⑭

**14. THE WORLD** – Whoever will be a friend of the world is the ENEMY of God. James 4:4 *"There is a way which seems right to a man... But its end is the way of DEATH."* Proverbs 14:12

 **THE FLESH** ⑮

**15. We fight the FLESH** – The FLESH is TEMPTED toward evil. *Galatians 5:19-21.* *"For —the lust.. of the FLESH and the lust of the EYES and... PRIDE of life...these do not come from the Father..."* 1 John 2:16

 **THE DEVIL** ⑯

**16. We fight the DEVIL** – *"Be sober, be alert, cautious at all times. That enemy, the devil, prowls around like a roaring lion seeking someone to devour... but RESIST him."* 1 Peter 5:8 Evil can be very ATTRACTIVE, even as an angel of light. *2 Corinthians 11:14.*

CAROLYN ERICKSON © 2021     COLOR AND SHARE #11

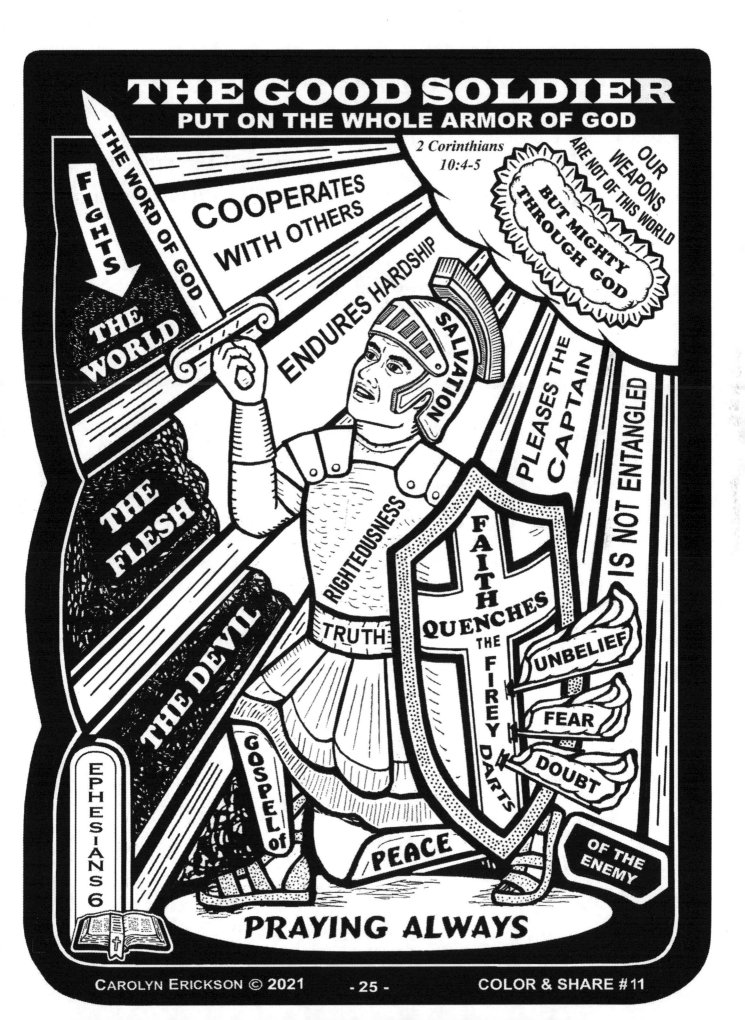

CAROLYN ERICKSON © 2021     COLOR & SHARE #11

# THINK ON THESE THINGS
## Phillipians 4:8

*"Finally, brothers, whatsoever things are TRUE, whatsoever things are HONEST, whatsoever things are JUST, whatsoever things are PURE, whatsoever things are LOVELY, whatsoever things are of GOOD REPORT; if there be any VIRTUE, and if there be any PRAISE, think on these things."*

**1. THINK ON THESE THINGS** - The BIBLE clearly tells us the KINDS of THINGS we should THINK about. *Phillipians 4:8*

①

**1. CAPTURE EVERY THOUGHT** - *"We capture every thought and make it... obey Christ." 1 Corinthians 10:3-6*

②

*Phillipians 4:8*

**2. "Whatsoever things are:**

③

**3. TRUE: To be like Jesus,** *"I am the TRUTH." John 14:6*

④

**4. HONEST:** *"Walk HONESTLY as in the day ...dress yourself with the Lord Jesus Christ." Romans 13:13-14*

⑤

**5. JUST:"** *But the path of the JUST (righteous) is like the light of dawn, That shines brighter and brighter..." Proverbs 4:18*

⑥

**6. PURE:**"*The Lord's orders are right. They make people happy. The Lord's commands are PURE. They light up the way." Psalm 19:8 ICB*

⑦

**7. LOVELY:** The beauty of God and His creation are LOVELY. *"My meditation of Him shall be sweet..." Psalm 104:34 AMP*

⑧

**8. OF GOOD REPORT** - Joyful things like the Gospel are OF GOOD REPORT. *"They continued to tell the GOOD NEWS - of Jesus." Acts 5:42 ICB*

⑨

**9. VIRTUE** - A life of VIRTUE is blessed. *"He who walks in integrity and with moral character walks securely." Proverbs 10:9*

⑩

**10. PRAISE** - *"O praise the Lord... all you people!" Psalm 117:1* *"So encourage... and build up one another..." 1 Thessalonians 5:11*

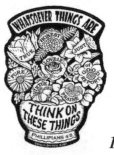

**THINK ON THESE THINGS** - *Phillipians 4:8*

*"but we have the mind of Christ."*

*1 Corinthians 2:16*

**CAROLYN ERICKSON © 2021**

**COLOR AND SHARE #12**

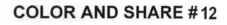

WHATSOEVER THINGS ARE

HONEST

TRUE

JUST

LOVELY

PURE

of GOOD REPORT

VIRTUE

PRAISE

THINK ON THESE THINGS

CAROLYN ERICKSON © 2021

COLOR & SHARE #12

PHILLIPIANS 4:8

# THE WORD OF GOD IS LIKE...

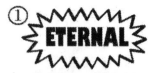

**1. ETERNAL -** God's Word is ETERNAL. *1 Peter 2:23*

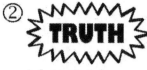

**2. TRUTH -** God's Word is TRUTH - *2 Samuel 7:28*

**3. JESUS is the WORD -** The Word became flesh and lived among us. *John 1:14*

## God's WORD is LIKE...

**4. A SWORD -** Reveals the heart. *Hebrews 4:12*

**5. FIRE -** Burns away the bad. *Jerimiah 23:29*

**6. MIRROR -** Reveals the self *James 1:23-24*

**7. WASHBASIN -** Cleans, purifies. *Ephesians 5:26*

**8. POWER -** To create faith. *1 Peter 1:23*

**9. LAMP-** A light to my feet. *Psalm 119:105*

**10. GOLD -** Better than GOLD. *Psalm 19:10*

**11. HAMMER -** Convicts of sin. *Jerimiah 23:29*

**12. SEED -** When we speak God's Word we are planting SEED. *2 Corinthians 9:10*

**13. RAIN & SNOW -** Refreshes, makes things grow. *Isaiah 55:10-11*

### THE WORD IS LIKE FOOD

**14. MILK -** *"Desire the MILK of the WORD."* *1 Peter 2:2*

**15. MEAT -** MEAT is for those that are more mature. *Hebrews 5:11-14*

**16. HONEY -** *"Sweeter than HONEY."* *Psalm 19:10*

**17. BREAD -** Man shall not live by BREAD alone, but by every WORD... of God. *Matthew 4:4*

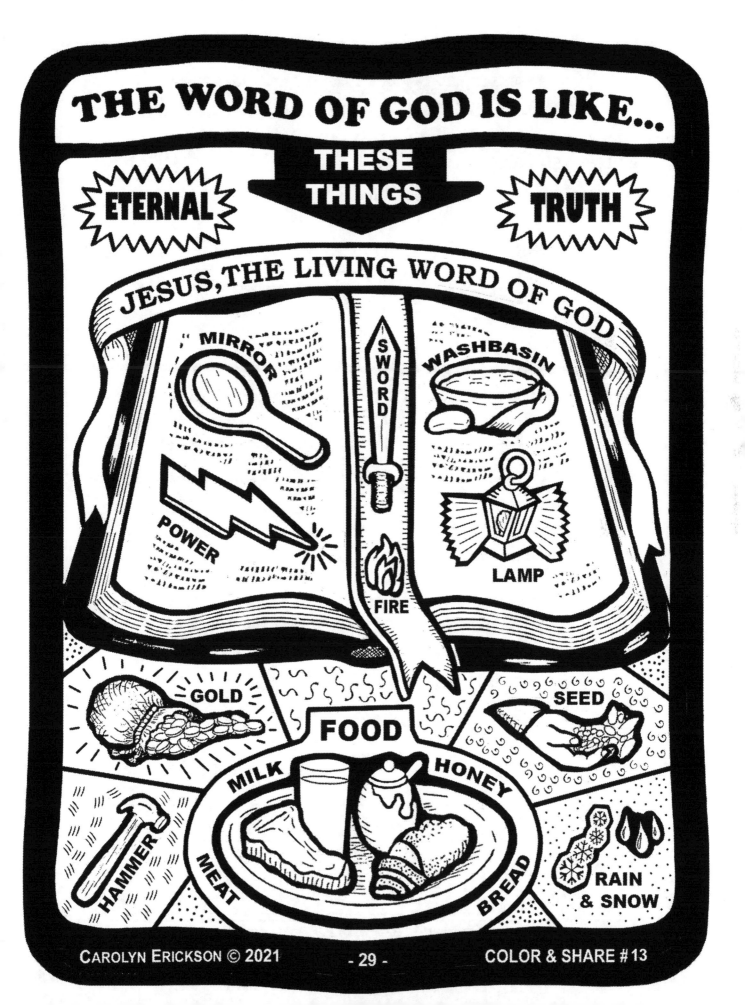

CAROLYN ERICKSON © 2021

COLOR & SHARE #13

# THE COMMANDMENTS: OLD and NEW

## ① TEN COMMANDMENTS

1. TEN COMMANDMENTS - **Exodus 20:1-17**
   Of the OLD Testament. (Covenant)

2. GOD gave His LAWS to the people of Israel **through Moses** - GOD wrote them on stone tablets. *Exodus 20:1-17*

**OF THE OLD TESTAMENT** ② UNDER the LAW

3. **OUR RELATIONSHIP WITH GOD** - Commandments 1, 2 3 and 4.

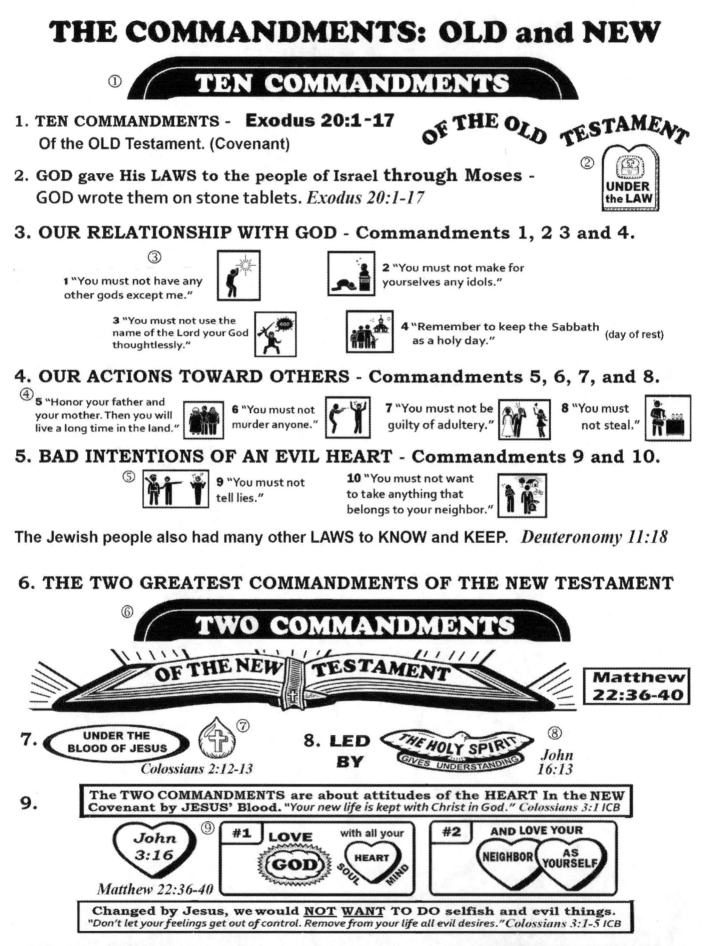

③ 1 "You must not have any other gods except me."

2 "You must not make for yourselves any idols."

3 "You must not use the name of the Lord your God thoughtlessly."

4 "Remember to keep the Sabbath as a holy day." (day of rest)

4. **OUR ACTIONS TOWARD OTHERS** - Commandments 5, 6, 7, and 8.

④ 5 "Honor your father and your mother. Then you will live a long time in the land."

6 "You must not murder anyone."

7 "You must not be guilty of adultery."

8 "You must not steal."

5. **BAD INTENTIONS OF AN EVIL HEART** - Commandments 9 and 10.

⑤ 9 "You must not tell lies."

10 "You must not want to take anything that belongs to your neighbor."

The Jewish people also had many other LAWS to KNOW and KEEP. *Deuteronomy 11:18*

6. **THE TWO GREATEST COMMANDMENTS OF THE NEW TESTAMENT**

⑥ **TWO COMMANDMENTS OF THE NEW TESTAMENT**

**Matthew 22:36-40**

7. UNDER THE BLOOD OF JESUS ⑦
*Colossians 2:12-13*

8. LED BY THE HOLY SPIRIT GIVES UNDERSTANDING ⑧ *John 16:13*

9. The TWO COMMANDMENTS are about attitudes of the HEART In the NEW Covenant by JESUS' Blood. *"Your new life is kept with Christ in God." Colossians 3:1 ICB*

**John 3:16** ⑨ #1 LOVE GOD with all your HEART SOUL MIND

#2 AND LOVE YOUR NEIGHBOR AS YOURSELF

*Matthew 22:36-40*

Changed by Jesus, we would **NOT WANT** TO DO selfish and evil things.
*"Don't let your feelings get out of control. Remove from your life all evil desires." Colossians 3:1-5 ICB*

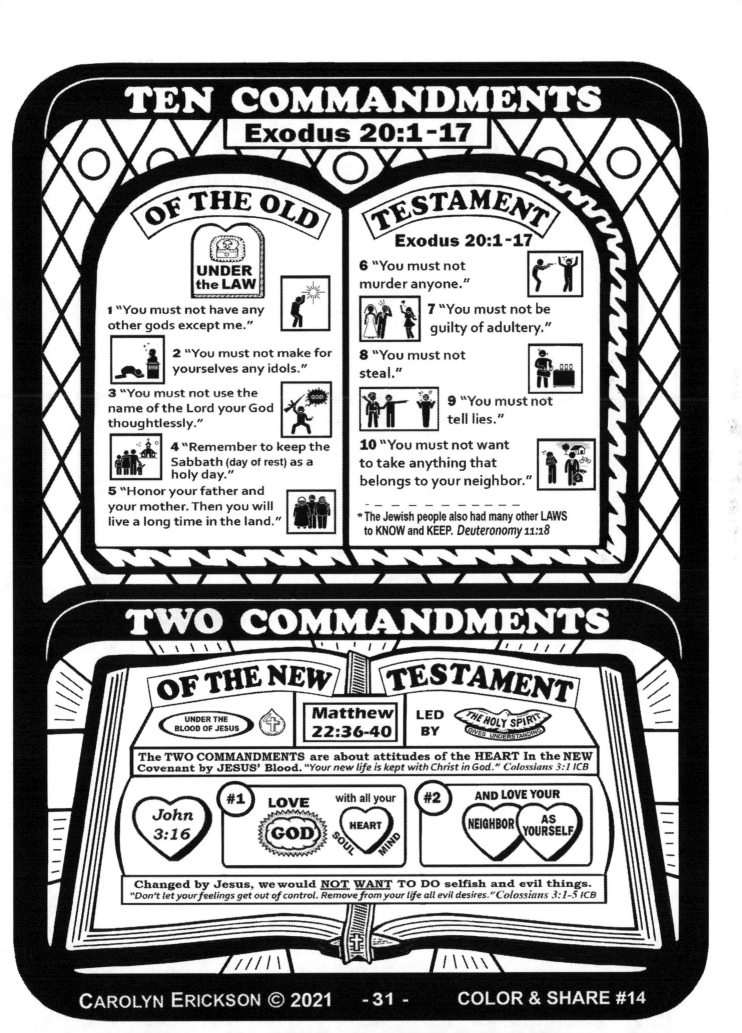

# TEN COMMANDMENTS
## Exodus 20:1-17

### OF THE OLD TESTAMENT
### Exodus 20:1-17

UNDER the LAW

1 "You must not have any other gods except me."

2 "You must not make for yourselves any idols."

3 "You must not use the name of the Lord your God thoughtlessly."

4 "Remember to keep the Sabbath (day of rest) as a holy day."

5 "Honor your father and your mother. Then you will live a long time in the land."

6 "You must not murder anyone."

7 "You must not be guilty of adultery."

8 "You must not steal."

9 "You must not tell lies."

10 "You must not want to take anything that belongs to your neighbor."

- - - - - - - - -
\* The Jewish people also had many other LAWS to KNOW and KEEP. *Deuteronomy 11:18*

# TWO COMMANDMENTS
## OF THE NEW TESTAMENT

UNDER THE BLOOD OF JESUS

Matthew 22:36-40

LED BY THE HOLY SPIRIT GIVES UNDERSTANDING

The TWO COMMANDMENTS are about attitudes of the HEART In the NEW Covenant by JESUS' Blood. *"Your new life is kept with Christ in God." Colossians 3:1 ICB*

John 3:16

#1 LOVE GOD with all your HEART SOUL MIND

#2 AND LOVE YOUR NEIGHBOR AS YOURSELF

Changed by Jesus, we would **NOT WANT** TO DO selfish and evil things.
*"Don't let your feelings get out of control. Remove from your life all evil desires." Colossians 3:1-5 ICB*

# THE SACRIFICE OF PRAISE
## Ways to Praise

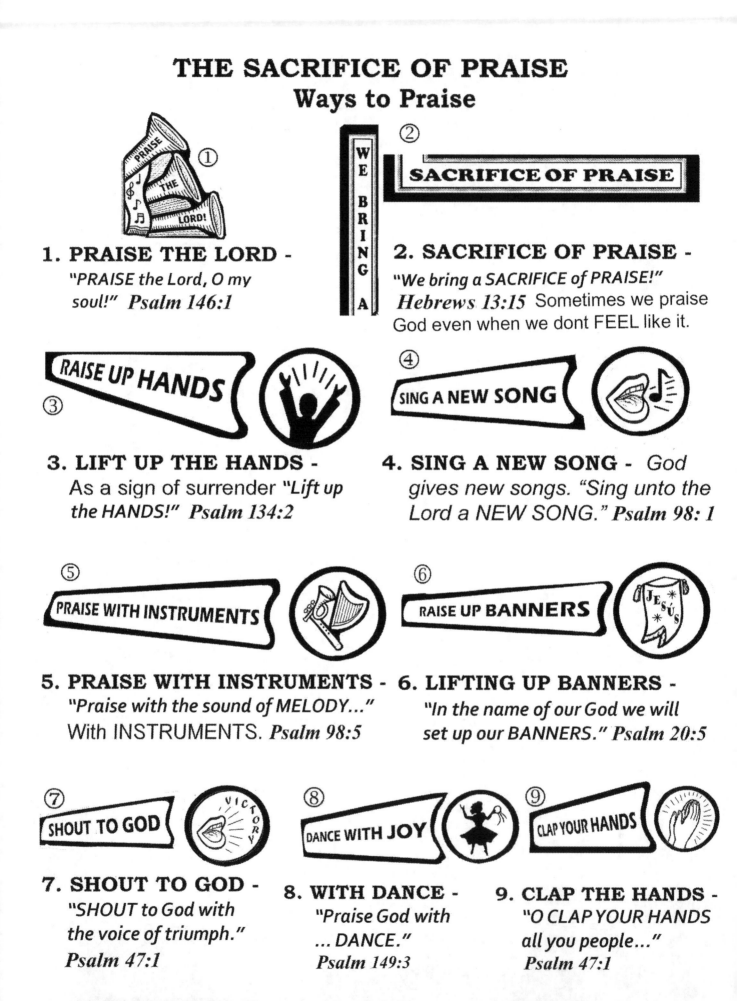

**1. PRAISE THE LORD -**
*"PRAISE the Lord, O my soul!" Psalm 146:1*

**2. SACRIFICE OF PRAISE -**
*"We bring a SACRIFICE of PRAISE!" Hebrews 13:15* Sometimes we praise God even when we dont FEEL like it.

**3. LIFT UP THE HANDS -**
As a sign of surrender *"Lift up the HANDS!" Psalm 134:2*

**4. SING A NEW SONG -** *God gives new songs. "Sing unto the Lord a NEW SONG." Psalm 98: 1*

**5. PRAISE WITH INSTRUMENTS -**
*"Praise with the sound of MELODY..."* With INSTRUMENTS. *Psalm 98:5*

**6. LIFTING UP BANNERS -**
*"In the name of our God we will set up our BANNERS." Psalm 20:5*

**7. SHOUT TO GOD -**
*"SHOUT to God with the voice of triumph." Psalm 47:1*

**8. WITH DANCE -**
*"Praise God with ... DANCE." Psalm 149:3*

**9. CLAP THE HANDS -**
*"O CLAP YOUR HANDS all you people..." Psalm 47:1*

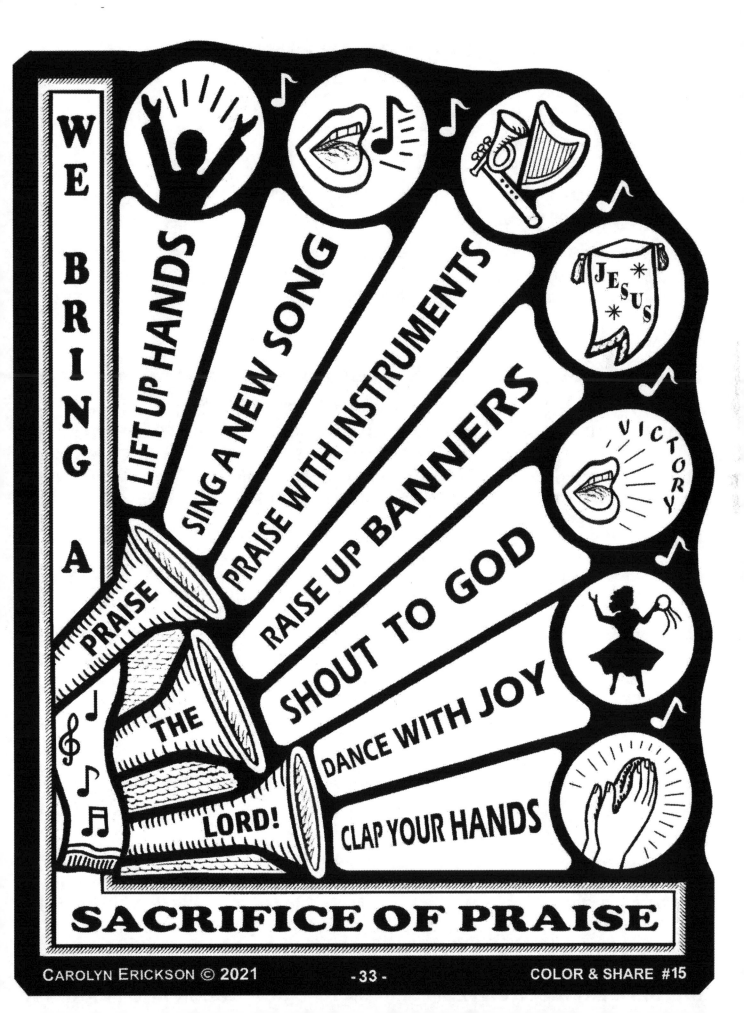

CAROLYN ERICKSON © 2021
COLOR & SHARE #15

# THE GOOD SHEPHERD
## Psalm 23 - John 9

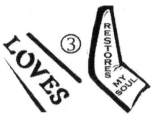

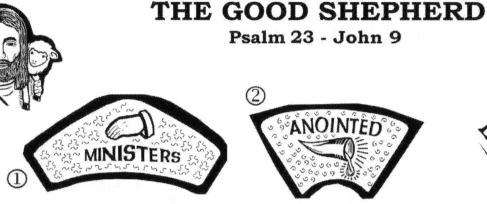

**1. MINISTERS** - The Shepherd MINISTERS to the sheep. (followers.) *Psalm 23:1*

**2. ANOINTED** - He is ANOINTED for his work. *Psalm 23:5*

**3. LOVE and COMFORT** - *"He RESTORES my SOUL." Psalm 23:3*

**4. HE BRINGS ORDER** - The ROD corrects, the STAFF helps guide. *Psalm 23:4*

**5. THE SHEEP LISTEN, LOVE and OBEY.** He cares for them. *"I shall NOT want." Psalm 23:1*

**6. THEY KNOW HIS VOICE** - *"A stranger they WILL NOT follow."* John 9:3

**7. HE FEEDS THE SHEEP** - *"Leads... in GREEN PASTURES." Psalm 23:3*

**8. HE LEADS IN PATHS of RIGHTEOUSNESS...** *"Beside STILL WATERS." Psalm 23:3*

**9. HE GIVES HIS LIFE** - He risks his LIFE, uses his time and energy, *Psalm 23:4*

**10. I FEAR NO EVIL** - for you are WITH ME. *Psalm 23:4*

**11. PREPARES OTHERS** - Teaches OTHERS to be undershepherds, leaders. *Ephesians 4:12*

**12. GOODNESS and MERCY** - Shall follow me ALL the days of my life. *Psalm 23:8*

**CAROLYN ERICKSON © 2021**    - 34 -    COLOR AND SHARE # 16

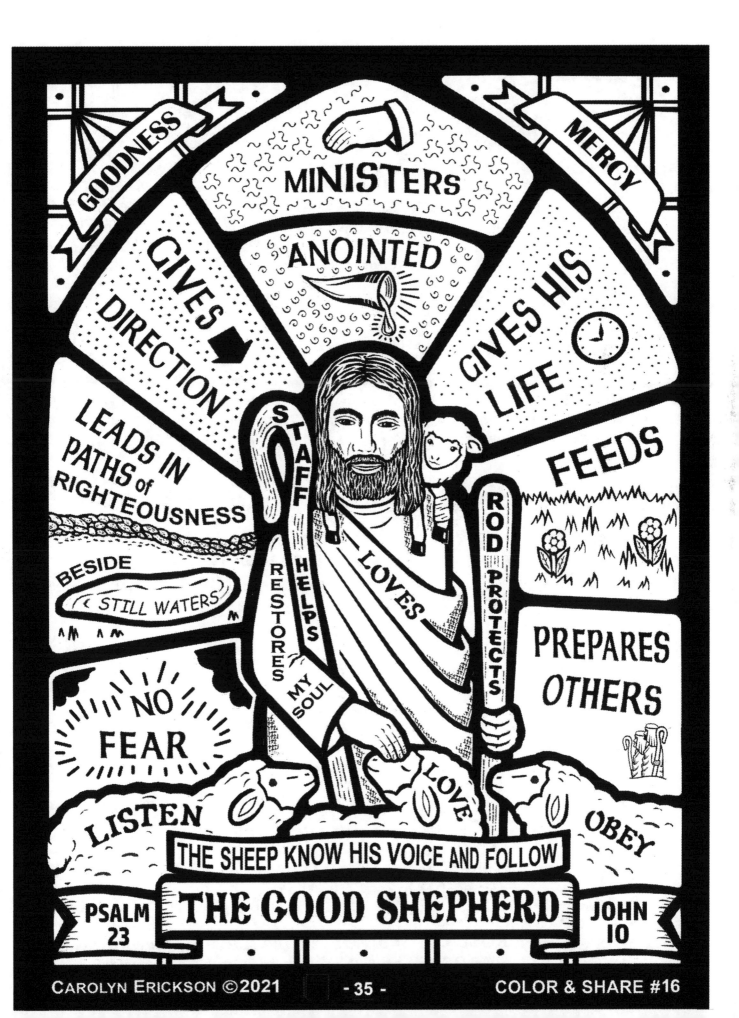

CAROLYN ERICKSON ©2021     COLOR & SHARE #16

# TITLES OF JESUS

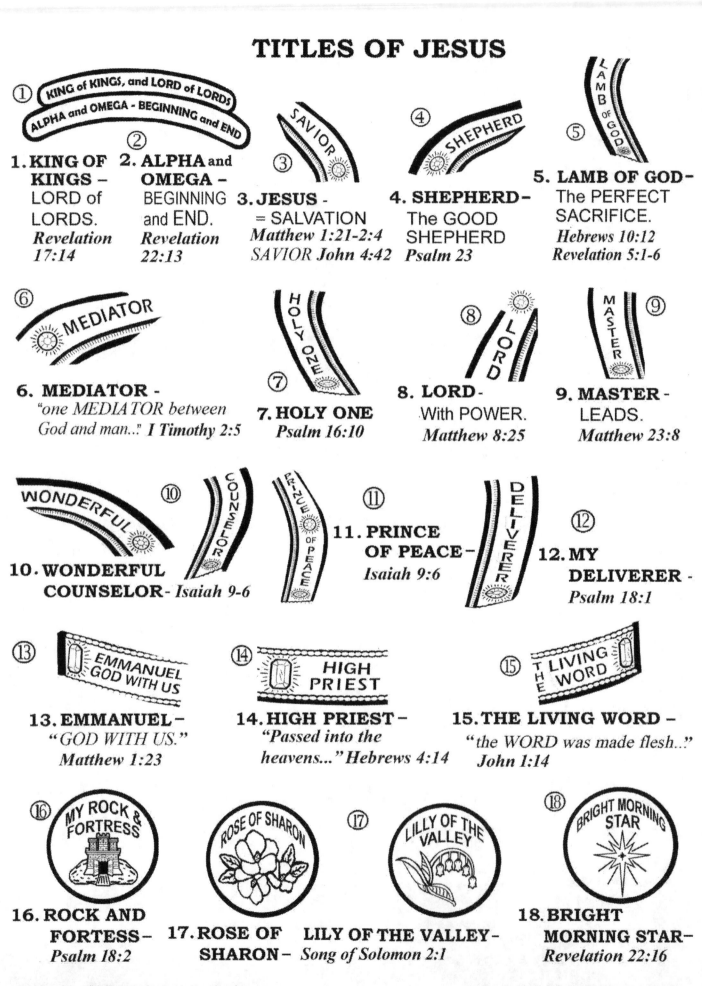

① KING of KINGS, and LORD of LORDs
② ALPHA and OMEGA - BEGINNING and END

**1. KING OF KINGS** – LORD of LORDS. *Revelation 17:14*

**2. ALPHA** and **OMEGA** – BEGINNING and END. *Revelation 22:13*

③ SAVIOR

**3. JESUS** – = SALVATION *Matthew 1:21-2:4* SAVIOR *John 4:42*

④ SHEPHERD

**4. SHEPHERD** – The GOOD SHEPHERD *Psalm 23*

⑤ LAMB of GOD

**5. LAMB OF GOD** – The PERFECT SACRIFICE. *Hebrews 10:12 Revelation 5:1-6*

⑥ MEDIATOR

**6. MEDIATOR** – *"one MEDIATOR between God and man.."* *I Timothy 2:5*

⑦ HOLY ONE

**7. HOLY ONE** *Psalm 16:10*

⑧ LORD

**8. LORD** – With POWER. *Matthew 8:25*

⑨ MASTER

**9. MASTER** – LEADS. *Matthew 23:8*

⑩ WONDERFUL COUNSELOR

**10. WONDERFUL COUNSELOR** – *Isaiah 9-6*

⑪ PRINCE OF PEACE

**11. PRINCE OF PEACE** – *Isaiah 9:6*

⑫ DELIVERER

**12. MY DELIVERER** – *Psalm 18:1*

⑬ EMMANUEL GOD WITH US

**13. EMMANUEL** – *"GOD WITH US."* *Matthew 1:23*

⑭ HIGH PRIEST

**14. HIGH PRIEST** – *"Passed into the heavens..."* *Hebrews 4:14*

⑮ THE LIVING WORD

**15. THE LIVING WORD** – *"the WORD was made flesh.."* *John 1:14*

⑯ MY ROCK & FORTRESS

**16. ROCK AND FORTESS** – *Psalm 18:2*

ROSE OF SHARON

**17. ROSE OF SHARON** –

⑰ LILLY OF THE VALLEY

**LILY OF THE VALLEY** – *Song of Solomon 2:1*

⑱ BRIGHT MORNING STAR

**18. BRIGHT MORNING STAR** – *Revelation 22:16*

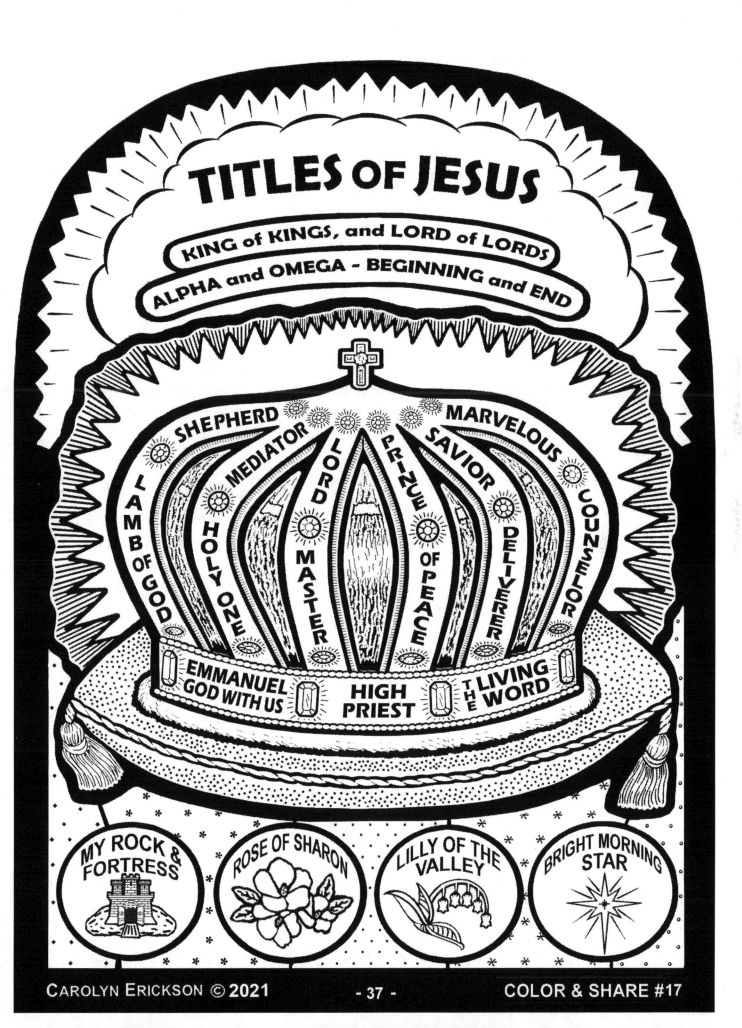

# THE HOLY SPIRIT
## Third Person of the Trinity

**THE HOLY SPIRIT**

① IS ONE WITH THE FATHER & SON

**1. HE IS ONE WITH THE FATHER and SON.** *"These THREE are ONE." 1 John 5:7*

② GUIDES  ANOINTS

**2. HE GUIDES** - *"He will GUIDE you into all truth."* John 16:13

**ANOINTS with POWER**- *"God ANOINTED Jesus."* Acts 10:32

③ REMINDS, BRINGS TO MIND JESUS' TEACHINGS

**3. REMINDS** - Brings to mind Jesus' teachings. *"He will help you REMEMBER all that I have taugh you."* John 14:25, 26 AMP

④ SENT BY GOD THE FATHER IN JESUS' NAME

**4. SENT BY THE FATHER**- *"When the COMFORTER has come, whom I will send from the Father…"* John 15:26 AMP

⑤ PRESENT FROM THE BEGINNING

**5. WAS PRESENT FROM THE BEGINNING** - *"The SPIRIT moved on the waters."* Genesis 1:1, Psalm 104:30

⑥ BAPTIZES WITH FIRE

**6. BAPTIZES WITH FIRE**- *"He wil BAPTIZE with the Holy Spirit and with fire."* Matthew 3:11 AMP

⑦ COMFORTER

**7. IS THE COMFORTER**- *COMFORTER. John 14:16* Was a DOVE at Jesus' baptism. *Matthew 3:16*

⑧ GIVES JOY

**8. GIVES JOY, EVEN IN AFFLICTION** - They *"received the Word with JOY."* 1 Thessalonians 1:6

⑨ A GIFT  GIVES GIFTS

**9. HE IS A GIFT, GIVES GIFTS** - *"He GIVES to each as He will."* Acts 2:38, 1 Corinthians 12:11

⑩ CAN BE PROVOKED

**10. CAN BE PROVOKED** - *"PROVOKE not the Spirit."* Psalm 106:7, 29, 33

⑪ CAN REJOICE  CAN BE GRIEVED

**11. CAN REJOICE** - *"in Spirit, I REJOICE."* Colossians 2:5
**CAN BE GRIEVED**- Ephesians 4:30, 6:17

⑫ SENDS MINISTERS

**12. HE SENDS MINISTERS**- Paul and Barnabas were SENT out. Acts 13:4

⑬ TESTIFIES

**13. TESTIFIES** - To the TRINITY, 1 John 5:7 Jesus: *"He will TESTIFY of me."* John 15:26

⑭ WORKS DECENTLY AND IN ORDER

**14. WORKS DECENTLY AND IN ORDER** - 1 Corinthians 14:39

⑮ CASTS OUT DEMONS

**15. CASTS OUT DEMONS** - Matthew 8:28-34

⑯ CANNOT BE RECEIVED BY THE WORLD

**16. THE WORLD CANNOT RECIEVE HIM** - The Spirit of TRUTH. John 14:17

⑰ Puts to DEATH THE SINS

**17. PUTS TO DEATH THE SINS OF THE FLESH** – *"-If by the Holy Spirit you are… putting to death the sinful deeds… you will live."* Romans 8:12-14

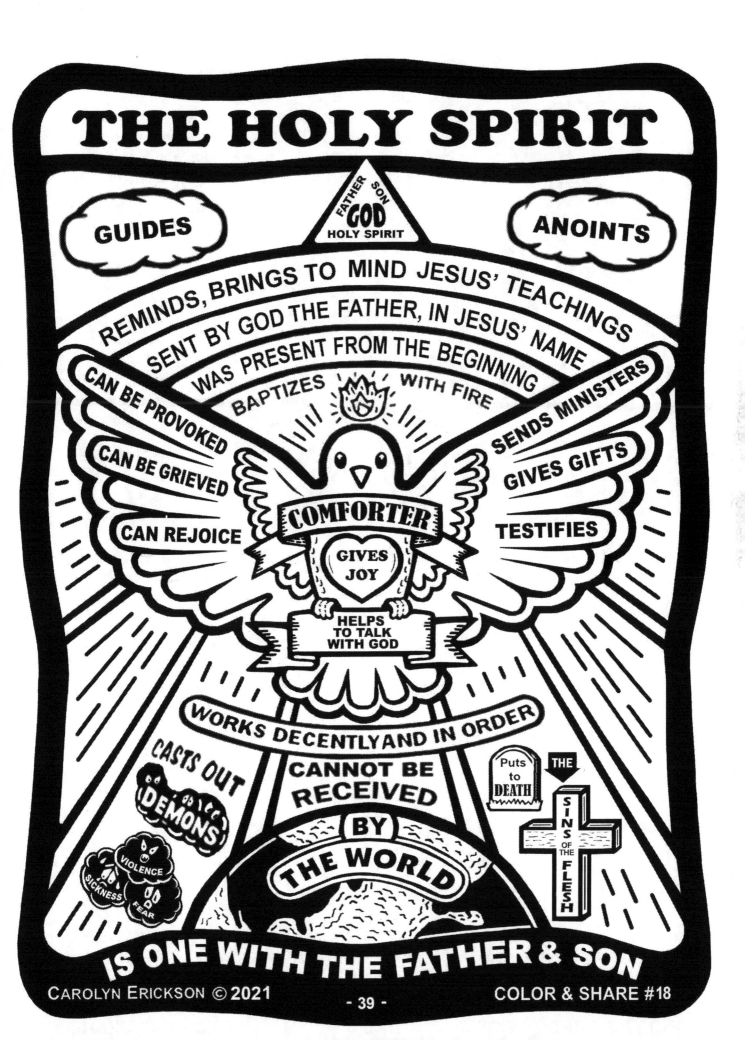

THE HOLY SPIRIT

GUIDES

ANOINTS

GOD
FATHER SON
HOLY SPIRIT

REMINDS, BRINGS TO MIND JESUS' TEACHINGS
SENT BY GOD THE FATHER, IN JESUS' NAME
WAS PRESENT FROM THE BEGINNING
BAPTIZES WITH FIRE

CAN BE PROVOKED
CAN BE GRIEVED
CAN REJOICE

SENDS MINISTERS
GIVES GIFTS
TESTIFIES

COMFORTER
GIVES JOY
HELPS TO TALK WITH GOD

WORKS DECENTLY AND IN ORDER

CASTS OUT
DEMONS
VIOLENCE
SICKNESS
FEAR

CANNOT BE RECEIVED
BY
THE WORLD

Puts to DEATH
THE SINS OF THE FLESH

IS ONE WITH THE FATHER & SON

CAROLYN ERICKSON © 2021

COLOR & SHARE #18

# JEHOVAH NAMES of GOD

In the Bible, there are many names used in referring to God. These are the names of God that begin with Jehovah, *(El, in Hebrew)* presented in the order in which they appear.

Here are the "Jehovah names," in the original Hebrew, and the meanings in English.

Names of God that begin with JEHOVAH

**2.** God the CREATOR of all things, seen and unseen. *Genesis 2:4-25*

**3.** The SOVREIGN God of the impossible, to give Abraham a son. *Genesis 15:2, 8*

**4.** ALMIGHTY, was how God introduced himself. *Genesis 17:1-3*

**5.** The PROVIDER gave a sacrifice for Abraham. *Genesis 22:8-14*

**6.** Our BANNER, at the miracle of water from the rock. *Exodus 17:15*

**7.** HEALER, when He made the bitter water sweet. *Exodus 15:26*

**8.** PEACE, when Gideon was frightened by an angel. *Judges 6:24*

**9.** RIGHTEOUSNESS, God to Jeremiah. *Jeremiah 22:6, 33:16*

**10.** SANCTIFIER, Instructing on purification. *Exodus 31*

**11.** LORD OF HOSTS, Israel going to worship at Shiloh: *1 Samuel 1:3*

**12.** PRESENT, measuring of Jerusalem: "The Lord is There." *Ezekiel 48:35*

**13.** David sang praises to GOD MOST HIGH. *Psalm 7:17 47:2, 97:9)*

**14.** The SHEPHERD'S Psalm. *Psalm 23:1*

**15.** Let us worship OUR MAKER. *Psalm 95:6*

**16.** Praising the GREAT GOD. *Psalm 99:1*

CAROLYN ERICKSON © 2021          COLOR AND SHARE # 19

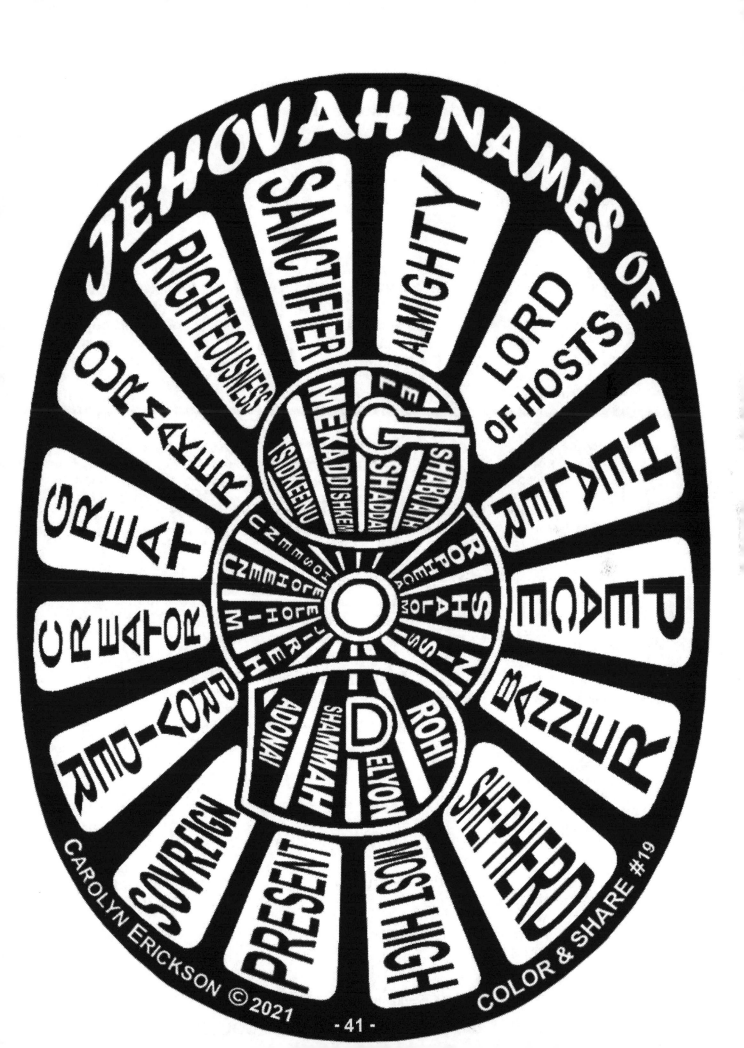

JEHOVAH NAMES OF

SANCTIFIER
RIGHTEOUSNESS
ALMIGHTY
LORD OF HOSTS
CREATOR
GREAT
HEALER
CREATOR
PEACE
PROVIDER
BANNER
SOVEREIGN
SHEPHERD
PRESENT
MOST HIGH

MEKADDISHKEM
TSIDKEENU
SHADDAI
SABBATH

ADONAI
SHAMMAH
ELYON
ROHI

CAROLYN ERICKSON © 2021

COLOR & SHARE #19

# THE CHRISTIAN FAITH
## The Foundations of the Faith
### The Christian Faith  *The Foundations of the Faith*

**1. THE INSPIRATION OF THE BIBLE** - The Bible is the Word of God, the true guide of our faith and actions...inspired by the Holy Spirit. *1 Timothy 3:15-16, 2 Peter 1:21*

**2. THERE IS ONE GOD, SHOWN IN THREE PERSONS** - The Father, the Son and the Holy Spirit.
THE TRINITY
*Exodus 3:14, Deuteronomy 6:4, Matthew 28:19, Mark 12:29*

**3. HUMANS: CREATION, FALL AND REDEMPTION** - Created by God in innocence. Adam and Eve fell into sin. The only salvation is through Jesus.
*Genesis 1:26 + 3:6-12 John 3:16-18, Mark 16:16*

**4. SALVATION COMES BY REPENTANCE FROM SIN** - We accept the forgiveness of God through Jesus, the only mediator between God and man.
*1Timothy 2:4-5 John 3:17, 1 Peter 1:18-20*

**5. SANCTIFICATION** - is a state of grace which keeps us apart from worldly things.
*1 Thessalonians 4:3-5, 1 Peter 1:14-16*

**6. THE BAPTISM IN THE HOLY SPIRIT** - with speaking in tongues is given to guide us.
*Matthew 3:11, Acts 1:8, Acts 2:4*

**7. DIVINE HEALING** - is recieved by faith, through the sacrifice of Jesus.
*Isaiah 53:4-6 1 Peter 2:21-25, Psalm 107:20*

**8. THE BODY OF CHRIST** - The Church, made up of believers, is the Body of Christ on the earth.
*1 Corinthians 12:27, Ephesians 2:19-22, Matthew 16:18*

**9. STEWARDSHIP, MONEY** - Responsibility of stewardship, tithe and offering.
*Malachi 10:10-11 Matthew 23:23*

**10. JESUS TAKES THE CHURCH** - Jesus comes for His own. The church is "caught up."
*1 Thessalonians 4:13-18, 1 Corinthians 15:51-52*

**11. JESUS RETURNS, THE MILLENIUM** - Jesus returns with his Saints, the Millenium.
*Revelation 6:12-17, Revelation 20:1-4*

**12. THE FINAL JUDGEMENT** - The Final Judgement of the unbelievers, who refuse salvation through Jesus.
*Revelation 20:10-15, Matthew 25:46*

**13. NEW HEAVENS AND A NEW EARTH** - New heavens and a new Earth.
*2 Peter 3:13, Revelation 21:22*

**14. WATER BAPTISM** - Water Baptism, a public confession of faith.
WATER BAPTISM
*Matthew 28:19, Mark 16:16*

**15. COMMUNION** - Communion, remembering Jesus' sacrifice.
*Matthew 26:26-28, 1 Corinthians 11:24-31*

**16. DISAPPROVAL OF FALSE TEACHINGS** - Disapproval of false teachings that are not biblical.
*Titus 2:1, 2 Peter 2:1*

CAROLYN ERICKSON © 2021

COLOR AND SHARE # 20

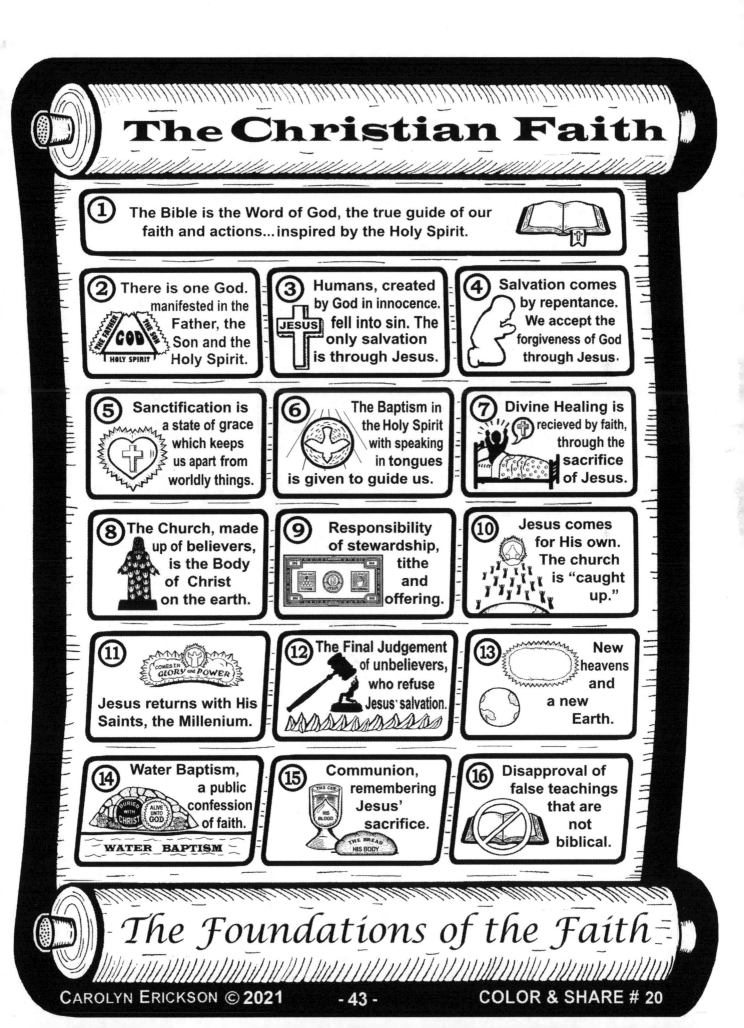

# The Christian Faith

① The Bible is the Word of God, the true guide of our faith and actions...inspired by the Holy Spirit.

② There is one God. manifested in the Father, the Son and the Holy Spirit.

③ Humans, created by God in innocence. fell into sin. The only salvation is through Jesus.

④ Salvation comes by repentance. We accept the forgiveness of God through Jesus.

⑤ Sanctification is a state of grace which keeps us apart from worldly things.

⑥ The Baptism in the Holy Spirit with speaking in tongues is given to guide us.

⑦ Divine Healing is recieved by faith, through the sacrifice of Jesus.

⑧ The Church, made up of believers, is the Body of Christ on the earth.

⑨ Responsibility of stewardship, tithe and offering.

⑩ Jesus comes for His own. The church is "caught up."

⑪ Jesus returns with His Saints, the Millenium. COMES IN GLORY and POWER

⑫ The Final Judgement of unbelievers, who refuse Jesus' salvation.

⑬ New heavens and a new Earth.

⑭ Water Baptism, a public confession of faith. WATER BAPTISM BURIED WITH CHRIST ALIVE UNTO GOD

⑮ Communion, remembering Jesus' sacrifice. THE CUP HIS BLOOD THE BREAD HIS BODY

⑯ Disapproval of false teachings that are not biblical.

## The Foundations of the Faith

CAROLYN ERICKSON © 2021

-43-

COLOR & SHARE # 20

# JESUS IS BORN
## God Sent Jesus Christ the Savior

**1. PROPHECY and FULFILLMENT** - Many prophecies and promises of the Old Testament were fulfilled by Jesus. Scriptures from the Old Testament are found again in the New. The first time Jesus taught in the Temple, this is what he read. *Luke 4:18-21*

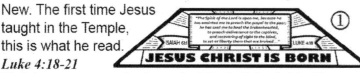

JESUS CHRIST IS BORN

Christ means one who is sent of God. *John 3:16 -17*

**2. BORN TO A VIRGIN** - An Angel announced to Mary that being a virgin, she would give birth by a miracle to a son sent from God. His name would be Jesus. *Luke 1:26-35*

ANNUNCIATION ②

**3. ANOTHER MIRACLE CHILD** - Mary's cousin Elizabeth's child became John the Baptist. Elizabeth spoke words from God to Mary, as proof of her miracle. *Luke 1:42-45*

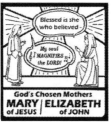

Blessed is she who believed
My soul MAGNIFIES the LORD!
God's Chosen Mothers
MARY of JESUS | ELIZABETH of JOHN

**4. JOSEPH WAS VISITED BY AN ANGEL** - Joseph, who would be Mary's husband, was afraid, so God sent him an Angel. *Matthew 1:18 -25*

Joseph, do not fear to take Mary as your wife.
JOSEPH'S DREAM ④

**5. THEY TRAVELED TO BETHLEHEM** - Jesus was to be born in Bethlehem, so before He was born they had to travel there. *Luke 2:1-5*

JOURNEY TO BETHLEHEM ⑤ NO ROOM

**6. JESUS BIRTH WAS FIRST ANNOUNCED TO SHEPHERDS** - ANGELS appeared, told of Jesus' birth and glorified God!! The shepherds went to see the baby Jesus and then they told everyone the good news! *Luke 2:8-18*

GOOD NEWS ⑥ GREAT JOY
ANNOUNCED TO SHEPHERDS

**7. BORN IN A MANGER** - There was no place to stay, so Jesus was born in a MANGER. *Luke 2:13* But in the sky a STAR appeared as the sign that a KING was born. *Matthew 3:10*

⑦ GLORY TO GOD IN THE HIGHEST!
PEACE ON EARTH, GOOD WILL TO MEN.
GOD SENT THE SAVIOR

AT THE TEMPLE SIMEON AND ANNA ⑧
My eyes have seen your salvation
Thank the Lord!

**8. SIMEON AND ANNA** - When Jesus was presented at the temple at 8 days old, two faithful long-time servants of God confirmed by the SPIRIT of GOD that Jesus was the promised one from God. *Luke 2: 21- 38*

**9. WISE MEN CAME, LED BY A STAR** - They asked King Herod where the KING of the JEWS was born. They were warned in dreams not to return to him as he had asked. *Matthew 2:1-12*

THEIR JOURNEY WAS LED BY A STAR ⑨
WISE MEN CAME

**10. THREE GIFTS OF THE WISE MEN** - They brought Gifts of GOLD, FRANKINCENSE and MYRRH that had special MEANINGS:
• Gold = King
• Frankincense = Deity
• Myrrh = Death. *Matthew 2:11*

MEANINGS:
Gold = King | Frankincense = Deity | Myrrh = Death
WISE MEN BROUGHT THREE GIFTS ⑩

**11. JOURNEY TO EGYPT** - An Angel came to Joseph in a dream, saying that Herod wanted to find and kill the new King. He told them to escape by going into EGYPT. *Matthew 2:13-15*

GO!
"GO TO EGYPT" Until King Herod died. ⑪

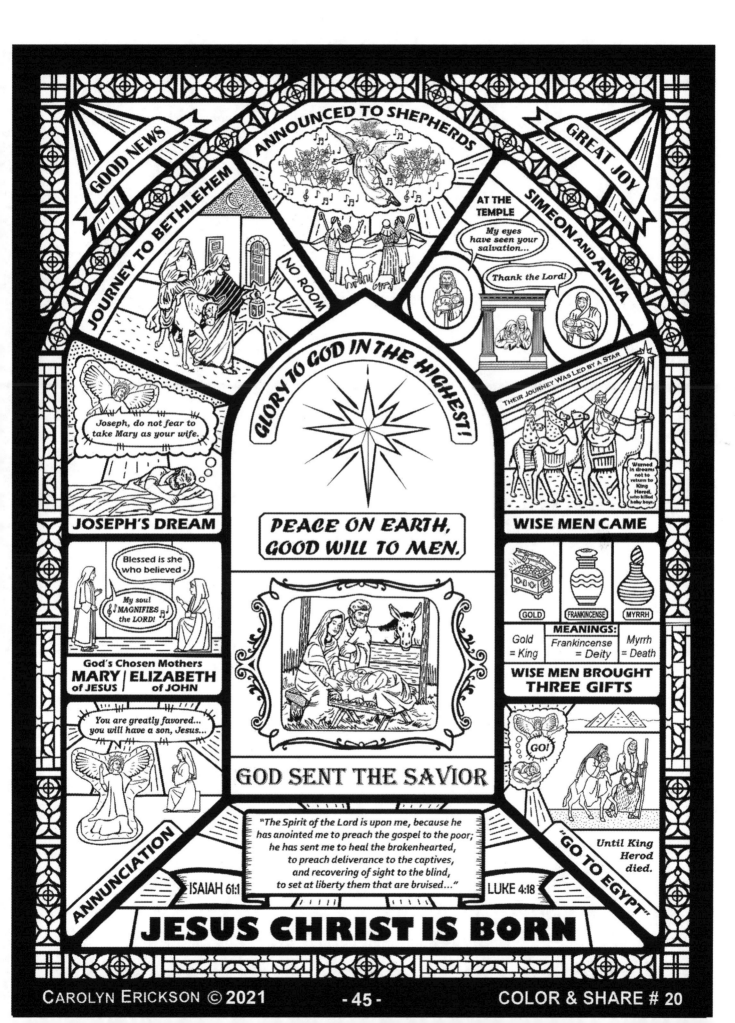

CAROLYN ERICKSON © 2021

COLOR & SHARE # 20